Different Skin

by Giorgia Lanuzza

Clink Street

Published by Clink Street Publishing 2024

Copyright © 2024

First edition.

ISBN:
978-1-915229-74-8 - paperback
978-1-915229-75-5 - ebook

Contents

Fun For All Ages! Get the kids to join in! Choose a picture and play DOT 2 DOT.

This book will change your life – But when you're done reading you will have to take over.

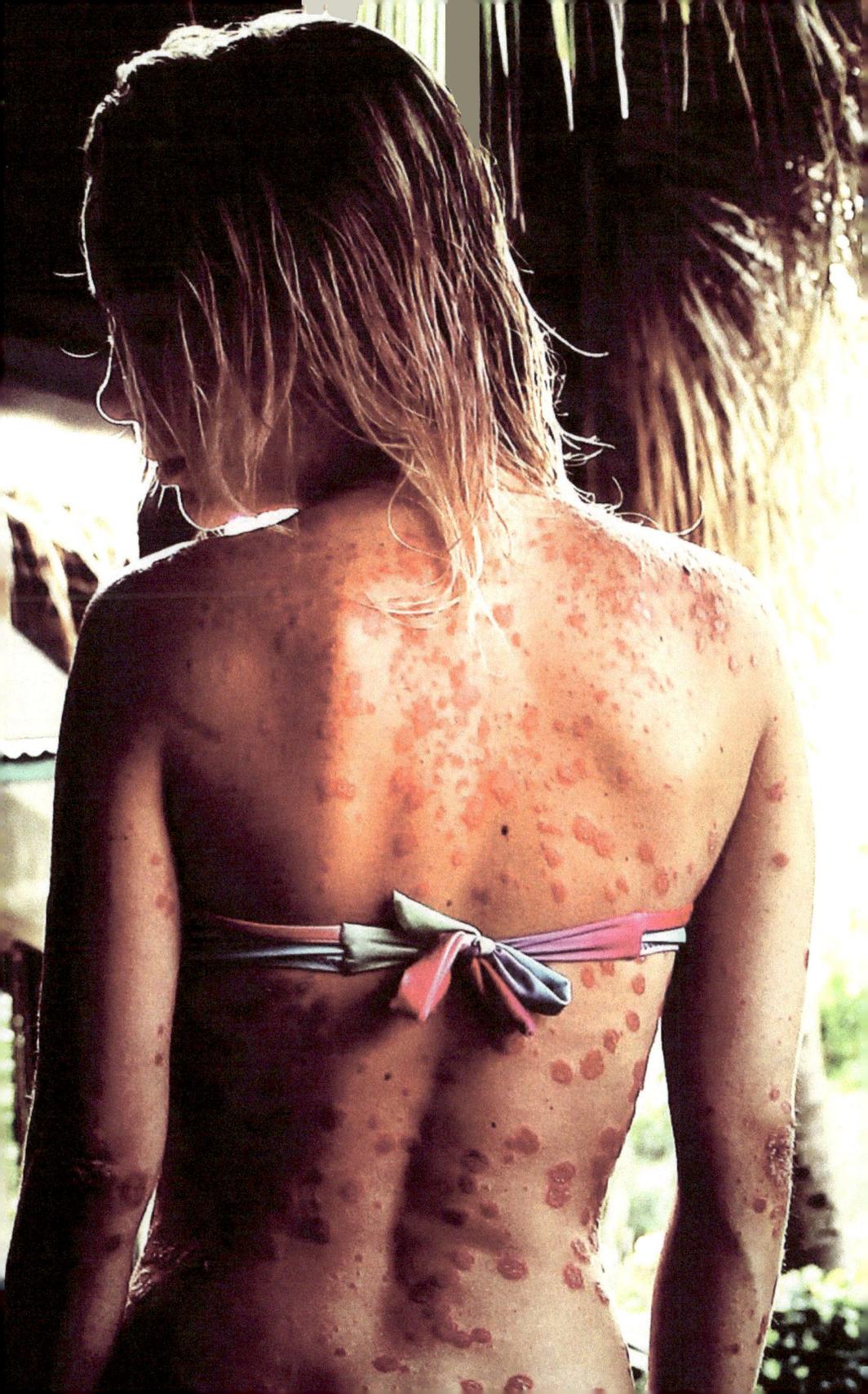

Nice to Meet You.

So here we are. It's been more than a few years since my name or, more accurately, my photos were in circulation. You may be familiar with who I am, whether you've known me as Giorgia Lanuzza

OR

That Girl with The Bad Skin.

The truth is, there is a bit more to it than that. When I shared my pictures in 2015, I knew they would shock the world.

That was my intention. I just had to show the world how the other half live. So different isn't shunned.

Because my own skin shocked me, I had to find out… Are there others in the world like me?

Who else out there is suffering so insanely? Are people walking this life – still hating themselves?

I wanted the world to open their eyes to life with psoriasis. But, as much as I wanted to create awareness and change perceptions, what I really wanted was to change what we tell ourselves as sufferers. And as humans.

Whatever it is you suffer with, be it mentally or physically, why should we keep ourselves in the shadows?

Why is it we are more scared of how we look, than how we are behaving and how we are perceived?

Since when did negativity and worry become an easier way to live? Easier than smiling or appreciating who we are, or the space and skin – that literally carries us through this harsh life?

No matter who you are… stress gets us all, every day, big or small. For 125 million people worldwide, psoriasis paints scales of our struggles. Using our skin as an outlet. As does eczema, acne and even allergies. I knew I wasn't alone.

But for those of us with different skin, we are stronger than we think. It's our skin taking one for the team. Although you might feel like you're in turmoil emotionally and physically – can you imagine if all of this didn't have that outer release?

Would it build up inside of us? With the rest of it?

I often thank my psoriasis…

Because, although it looked angry, sad & unfair on my skin, on the inside, it left my mind calm, happy & positive. Some say we are only dealt the cards we can handle in life… Confused much? Me too. This should be taken as a lesson. Right? As crazy as that was, eventually, I learnt that if that's true and someone out there has decided that I, Giorgia Lanuzza, am strong enough to handle the amount of trauma I've gone through – in a measly 32 years….

I must be A FUCKING TITAN!

If someone out there thinks I can handle all this. Then thanks for the compliment. I guess I really am that strong!

But we don't start out strong, do we?

The hardest thing to cope with was the fact most people are unaware of psoriasis and can make a split-second judgement about you, based on something you are not able to help.

That's when self-hate creeps in…

That's certainly how it all started for me. But the best thing about my psoriasis is that it has truly made me the person I am today. I am more confident now people see me for the real me – I'm pretty different, so get used to it.

I have always tried to show people; "if I don't hide it or care about how I look, why should they?" But also, it has made me realise we cannot judge anyone – no matter what they have that makes them different. I am fascinated and appreciate difference in all it's rare forms. Because, let me tell you, I sure as hell didn't appreciate it in myself when I was just a teenager… and needed to most.

I finally changed when I realised being different was making me a better person. So, I've told you when my life changed. But I should tell you how as well…

It was August 2004 when it happened. I was living back in Basingstoke with my mum, my stepdad, and my two brothers. And summer was in full swing.

My eldest brother and I are half Italian, you see.

We were all booked up to do our usual summer trip to Italy, to finally see our dad and our beautifully huge family out there.

With our dad being from Sicily, Italy, and our mum English born, my summers growing up were spent on the beach with Dad.

It was paradise.

Every year, buzzing with excitement, my suitcase was already packed weeks in advance – and this year was no different.

Until it was… On the 3rd of August 2004, just 10 days before our next visit, life as I knew it changed forever.

Dad was involved in a motorcycle accident and killed instantly.

He was just 46 when he died.

Our daddy was gone.

That day changed us as a family, forever. My brother was just 15. We were just kids.

To say it was a devastating time would be massively understating it. I honestly feel like I died in the weeks following. I was an empty vessel… with a new pattern.

– As that's when the first signs of the skin condition appeared.

I was only 13.

And so came my rebirth, I guess. My outlook on life changed when I lost my dad. But my outlook on myself was about to change me into a new person as well. It was so difficult for a lost 13-year-old girl to come to grips with, and I had no idea how hard life was going to be.

At that point, I was desperately unprepared for what was to follow.

I was just an immature kid. How the hell was I going to navigate through life when I was already being beaten by it before it had started?

My mum suffered with psoriasis before she had children and was horrifically bullied for it – I knew I wasn't going to allow that to be my story.

But I was new to my own skin, and even though I was wearing it… I was just as freaked out as my audience. But I couldn't let them know. I couldn't

let anyone know how much pain I was in: because that would mean showing them and exposing the horrible truth under my clothes.

I learnt quickly that a reaction is immediate, and others will judge without meaning to. This made it hurt so much more.

If I hadn't put cream on for a few hours, I would start to tighten and dry up, scales gathering under my layers as I secretly scratched to relieve the discomfort.

It was crazy learning to hide such a huge part of myself.

I've had some very serious cases of psoriasis over the years. And good diet, exercise or even a three-day bender… made no difference to my skin. For some reason, it never has.

This is how I quickly gathered – and doctors agreed – that, although most outbreaks of psoriasis can be down to diet or lifestyle, it was clear; it was deeper than that for me.

My skin was being ruled by my mental state, instead of my body.

It's Catch 22. When your psoriasis is caused by stress, life starts a harsh cycle: getting psoriasis because you're stressed, and then getting more stressed because you have psoriasis. Crying because of it, was creating more of it to cry over… and unfortunately, such was my life.

I didn't know how I was going to cope.
I lost my dad and lost who I was. I became a different person.
I was broken… How was I going to fix this?

It was clear I needed to tell others my story and how grieving and stress literally left me in this skin.

After a while, I started to own my own skin, and it changed how others saw me.

I refused to hide or lose who I was anymore.

It is incurable and it is now who I am.

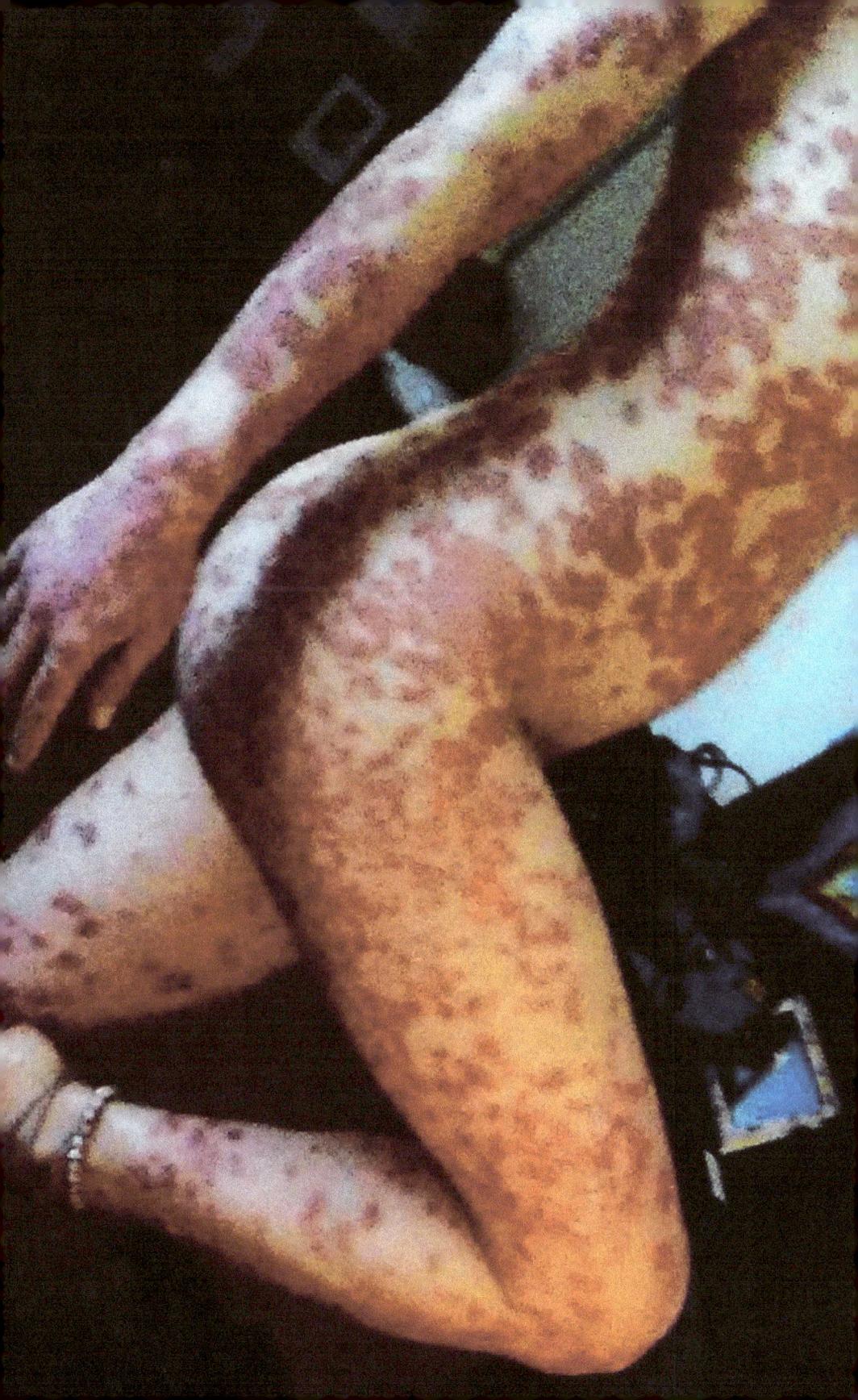

"What the F*** is Psoriasis?!"
(Or what the internet will tell you...)

Psoriasis is a skin condition that causes red, flaky, patches of skin covered with silvery scales. The patches normally appear on your elbows, knees, scalp, and lower back but can appear anywhere on the body. Around two per cent of the UK population, 1.3 million people, are affected by the condition, which can start at any age.

For most, psoriasis develops before the age of 35 and the condition affects men and women equally. The severity of the condition varies from person to person, for some causing a minor irritation, while for others it has a major impact on their quality of life.

Psoriasis is a long-lasting, or chronic, condition that involves periods when a sufferer will have either no symptoms or mild symptoms, followed by more severe outbreaks.

The condition occurs when the process by which the body produces skin cells is accelerated. Normally the cells are replaced by the body every three to four months, but in psoriasis, the process lasts only about three to seven days. The resulting build-up of skin cells creates the patches associated with psoriasis.

While the condition is not fully understood, it is thought the increased production of skin cells is related to a problem with a person's immune system.

For those suffering with the condition, their immune system attacks healthy skin cells by mistake.

Psoriasis can run in families and there is thought to be a genetic element to the condition. Many sufferers will experience symptoms following a certain event, a trigger. – A trigger can include stress, injury to a person's skin and throat infections.

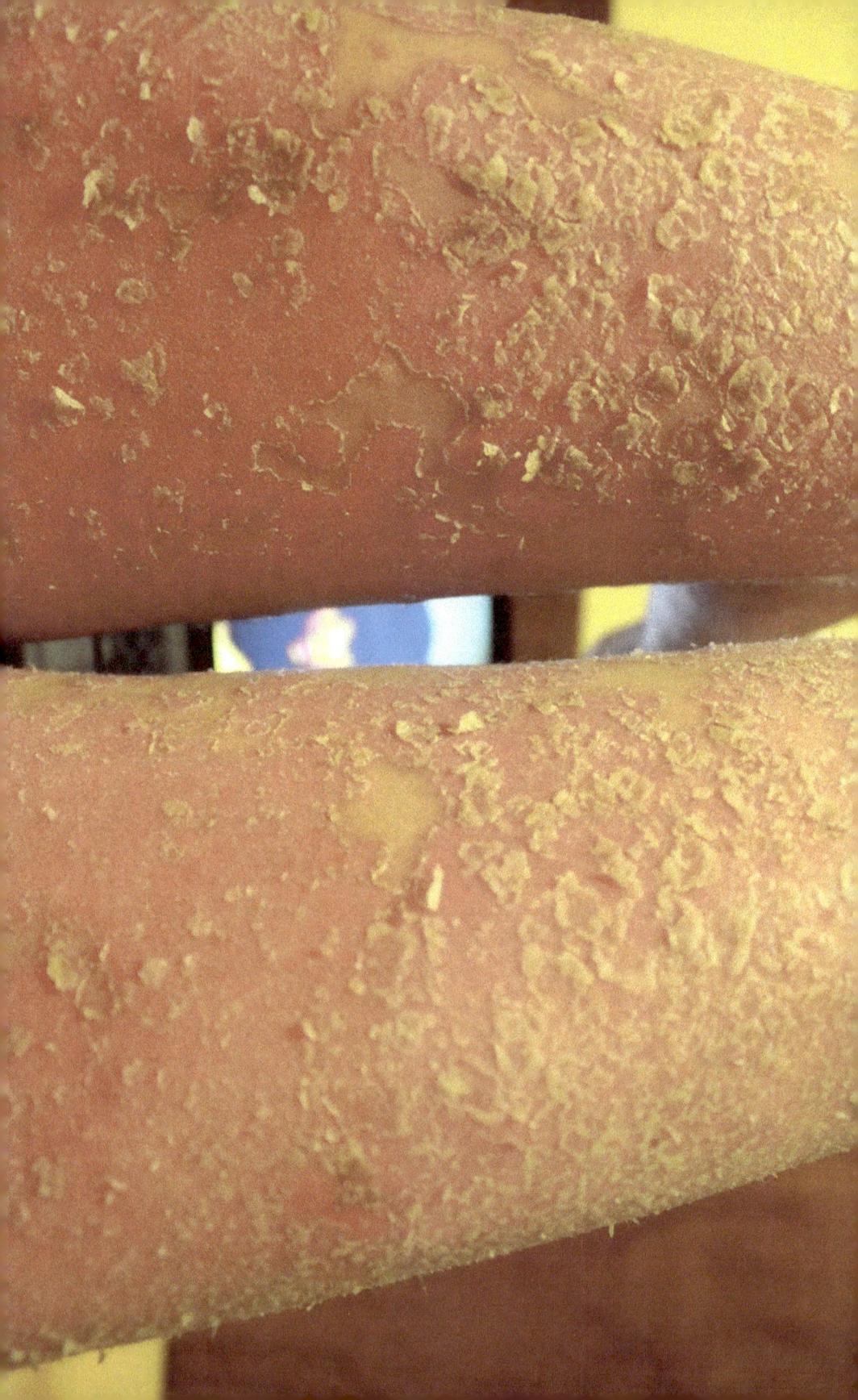

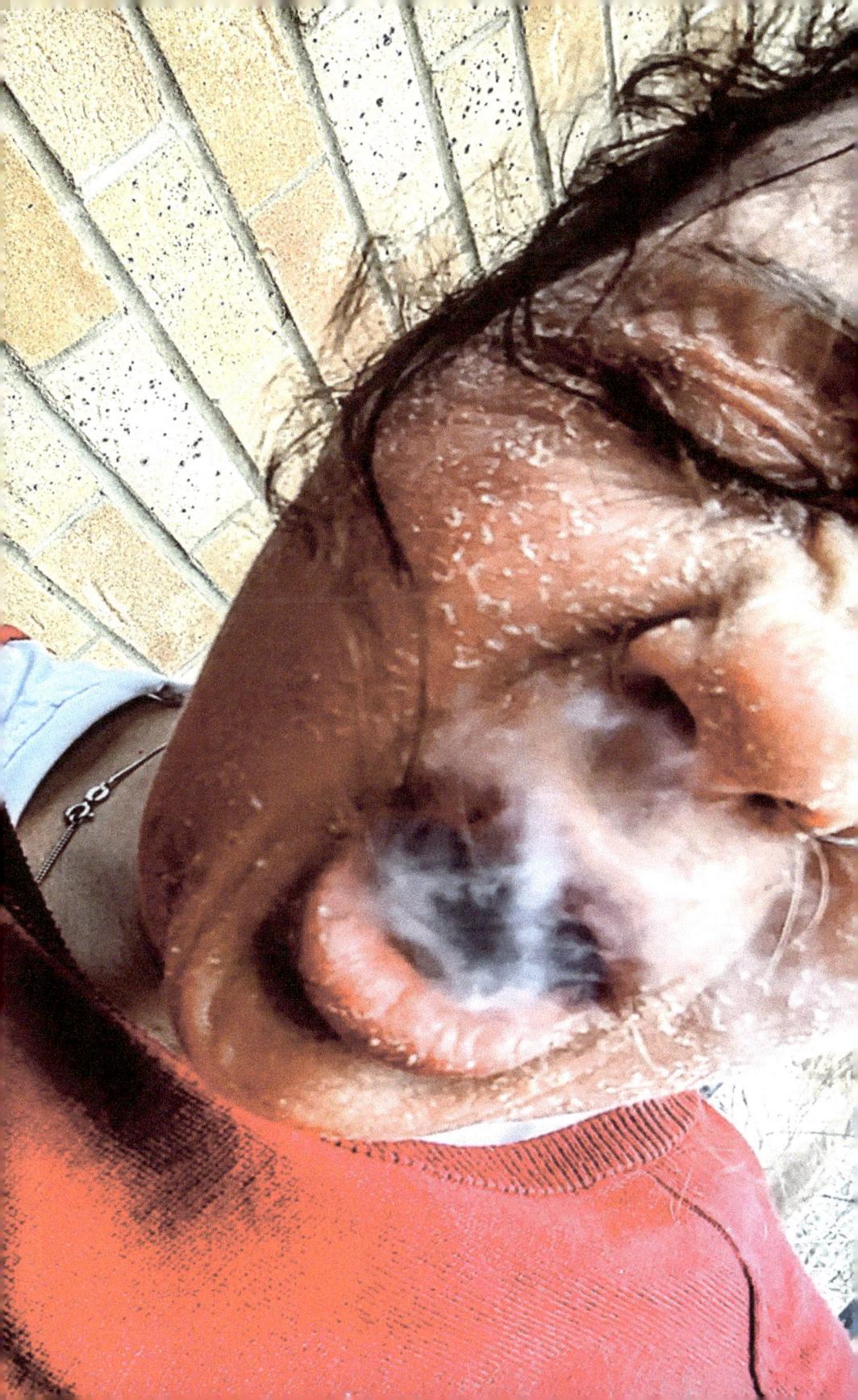

<u>Broken</u>

I got high grades at school, just not the right ones.

Do we think that may have stunted my tolerance for learning and teachers alike? Who knows? The thing is, at that age and with a shattered heart, weed saved me.

And it was my first true love. Just picture this:

Our relationship was forbidden, but once I had felt the effects and the numbing sensation of calm, I craved the sweet marijuana like the forbidden fruit.

In the beginning, we had to rely on stolen moments of excitement, where I would make sure the coast was clear before rescuing my One True Bud. And, finally prepping the moment, being alone, and rolling it up tight. I knew I needed to keep the fire in this relationship, to feel that spark again.

By the time THC & ME were serious, it was my life. But if I wasn't stoned and chilled, I'd spend my evenings crying over Dad and my skin. With no money, no car and parents still enjoying the bliss that comes with ignorance…

Most evenings were spent waiting nervously, clutching my Nokia 3210. For the reply. The only words that mattered…

"Yeah, how much do you want?"

It wasn't easy, I found a lot of lows in life before I found the highs.

Perhaps it was my devil, wanting a bit of fun after all the sadness. Maybe the devil felt sorry for me?

I hate that, back then, this was how I coped.

I wish I could have been stronger.

By the time I was out of school and the pressure of college had worn off, life just seemed to flow better; I cried a lot less and began to find myself.

But when life hit me, and I couldn't come back quickly enough, I would resort to the crazy fun lifestyle that, really, I hope everyone gets to enjoy one time in their life.

I was never out of control. To be honest, it somehow grounded me. Although my feet were grounded, my mind was not. When I was happy, so was my skin.

I used to fill my life with alternative pleasures to be happy and forget my pain, and I was *finally* laughing again. I had a great friend group and we lived, laughed, and spent every moment in a euphoric blast.

In a sense, this is how life should be in your early 20s.

It was a time in my life that was ultimately very necessary.
Because it brought me to where I am today.

I'm not perfect now, but I'm a bloody angel compared to who I was.

I'm sorry I used to drink to come out of my shell, I'm sorry I used to smoke to numb my pain, and I'm even more sorry for the period I became friends with Charlie.

Just to be productive and complete my 'To Do' list and forget the sadness that was overwhelming me.

But eventually, we all have to grow up.

Most of us change our lives for our kids, our loved ones and ourselves. We have to.

I suppose there are many things in life that can get on our tits or break our balls. And now we can't reach for the drink or drugs to forget our worries. Because now, we have to deal with them.

We live with massive responsibilities and pressures on a day-to-day basis, and I'm not allowed to be wavy to get me through it all?!

– That, my friends, is personal growth.
Or 'adulting' as we like to call it.

It's not only big stresses that can force us into a negative mood though, is it? It can be as simple as waiting for our favourite programmes to buffer, effing and

blinding at the TV because we just DON'T HAVE THE PATIENCE! Or it can be waiting for Alexa to stop talking bollocks and FULLY UNDERSTAND US! Or how your jumper only gets caught on the doorhandle when you're annoyed.

Illegal pleasures will always have a place in this world. But they don't fix the problem, they just slow the bleeding.

So, what's the point?

The thing is, now I spend my time trying to check myself and stop myself from stressing over the day-to-day issues.
The problem is, sometimes we just can't help it, can we?

I'm constantly thinking of the pressure and expectations I need to live up to. For myself. For my dad. And for my kids.

What we need to realise is… this life is all we have.

We are worth the time it takes right…? To get it right.
So, take a quiet moment and take a deeper breath, because you are worth the time it takes to get you there. It's about realising where you want to be and knowing you can do it. You can be happier than you are right now.
I was a wreck until I realised the best version of me wasn't out of reach.
Now past mistakes don't eat me up… or hold me back.

Life is a bitch. But what is it trying to teach us? We have to dust ourselves off and make it happen for ourselves… Right?

Don't live your life in any more upset and pain.
Don't live your life in any more stress and worry.
Don't live your life now, thinking it can't be achieved.
Aim for what you want and focus on making your dreams a reality.
If we can make vodka from a spud, think about what you could become!

Are you happy with where you are? Can you do more to make yourself truly proud?

I realised my legacy is more important than my past.

When that clicked, it started to drive me. And now I know where I'm going.

We are strong when we are aware of our weaknesses, and we become stronger by recognising our own flaws.
This helps us learn more from our choices and mistakes.
Because when we do this, we learn to be nicer to ourselves. We are allowed to fuck up, it happens.

So don't be so hard on yourself anymore.

Recognise what you don't like about yourself and make the changes that will make you proud and happy to look in the mirror.
Self-pity gets boring quick, and all it does is suck us down further into a tornado of negativity. Trust me, I know.

We are going to take up space in this world and we are allowed to fail. But don't let your failures bring you down for too long. Learn as quickly as you can to find the silver linings to the epic fails.
Don't wait for retrospect – That takes a while.

Where you are now could be just the start of your journey, you could be training your brain and controlling the negativity that life throws at you, as we speak.
Or you could be lost… right now. And unsure of where to turn.
You have to get that devil off your back – telling you you're not good enough.
Your current lifestyle or circumstances don't determine where you'll end up. This could just be your starting point.
If you are not happy, change. Change what you can, to become the happy person you truly deserve to be.

We all deserve to be happy. We should all be enjoying this life.
It's heartbreaking to know so many out there are miserable, depressed and feeling alone.

But we can't give up.

It's ok *not* to be ok sometimes, as long as we don't give up.

Please don't give up.

Healing takes time but aren't you worth it?

You'll leave the bad behind when you see the good in yourself.
Nothing in this world is more important than our mental state. Nothing makes life clearer than assuming control of your own mind.
Stopping negativity is a superpower. It really is!

Controlling your brain feed is paramount if we are to survive this life. This version of self-care will save you. Even if you feel you don't need saving.
Consider this… every good thought you have about yourself and your life, is a step closer to making it a reality.

Maybe we really can dream up the life we want. Because even if you have life under control, are you happy?

We all want to win at life. We want to know we have done the right thing, and we all want to leave a legacy enforcing and empowering our true authentic selves.

How far will you push yourself to make that happen?
I've been there; I tell you about certain things in my life because you have to know you are not alone.

I can't tell you everything… not yet. We'll see how this goes.

We protect ourselves by not leaking certain troubles into the world. We only show the good and the fantastic online, right? But how many of us are as happy as our social media portrays? I was all about that… of course, we want to show the world that we are content and that we are succeeding, only to hide the true stresses we are dealing with. But how much do we hide from the world and how much do we hide from family, or even ourselves?
We hold in so much, causing build-up and – eventually – a love-hate relationship with ourselves and our own minds.

It's not about what we are going through right now. It's about who we are and what we have inside of us that can push us further to be happy, instead of over the edge.

I am committed to myself. I am committed to only allowing positivity in. I will not allow myself to be beaten anymore by this life and the struggles it relentlessly brings.

I'm a strong person, but I'm not made of steel.
But if so many of us believe 'everything happens for a reason' then why is it so hard to turn our shit into our shine?

Every loss, every heartache… everything, has brought me to this place I'm in right now. It doesn't happen overnight, but sometimes, things just click.
You see the silver lining, and you learn the lesson.
And you become stronger each time.

You no longer worry about your choices because you trust your decisions.

We can't live this life assuming it's all meaningless. That we struggle for no reason. It might take retrospect, but that's just it. It is how you deal with your pain that proves the lesson in the end.
You will look back, and you will see yourself.
But what will you see?
Will you be proud of who you were and how you acted?

Let's face it, dusting yourself off after an earthly beating is always something to be proud of, no matter how we do it or how long it takes us.

I'm 32 now, and, so far, I have lost and grieved over eight people in my life – as well as my two cats. They were my boys… Mine.
Family and friends just taken away from me.
And no, sometimes I didn't cope in the best ways. I beat myself up in more ways than one, causing me to go deeper and deeper into self-destruct mode.

Some things you just can't make sense of. Healing through grief is so hard.
So, I had to change the way I think, or I'd never get through it.

It's the grieving that made my skin flare up.

And without that, and my camera – I wouldn't be here today. Doing this and feeling like my dad would be so proud.

…Because I did it. I turned my biggest pain into my biggest triumph.

We all have the capacity to feel so much, all at the same time. And it really is up to us to pull through.

I was done beating myself up and only told myself good things.

It's crazy when you realise you have to control it yourself.

Sometimes we have to pull through alone… Now that's hard. And so, for anyone out there doing it alone, know that you are strong enough…You can't be defeated.

Don't allow it!

You are a beast, a warrior. And someone truly worthy.

We have to allow the flow of the universe to give us the lessons we need. Because deep down, we got this.

Do you think I started off this strong? This capable?

Of course not. It's coming up out of the wreck that has made me this strong-willed. It's knowing I'm not alone.

Even though my people are gone from this world, they haven't left me.

I know my lost ones are somewhere watching me. And it's them I'm still fighting for, every day. It's them I still want to make proud, every day.

It's so hard to explain what I believe…

But I believe in something, I know my dad is up there pushing me to be better. And I feel his push more when I push myself.

There's a well-known saying: "Witches call it spells, the religious call it prayer, spiritualists call it manifestation, atheists call it the placebo effect and scientists call it quantum physics.

We argue over the name, but we don't argue over its existence." - Original source unknown

What we choose to believe, helps us. Have faith in yourself. And if we can learn to believe the right way, the right thing, it can help us try harder, fight harder… and propel us forward.

We have to love who we are and live confidently, knowing we can work for what we want and make the ones we want proud, whether they are still with us or not.

We are not robots, we are allowed to divert from the teachings of our family, our schools, and our environment.

It's great to have belief… But do you believe in yourself?

We all lose direction sometimes, but what if we are being guided, and we have to become stronger somehow before we can progress, or reach the end?

Your life is waiting for you to live it.

When I see someone crying through grief, I want to shake them and say, "They are still with you!"

When you believe that, you fight so much harder for yourself.

If you're lucky enough to still have your parents and family around you, appreciate them. Because soon they may leave. …So might you, so leave something wonderful.

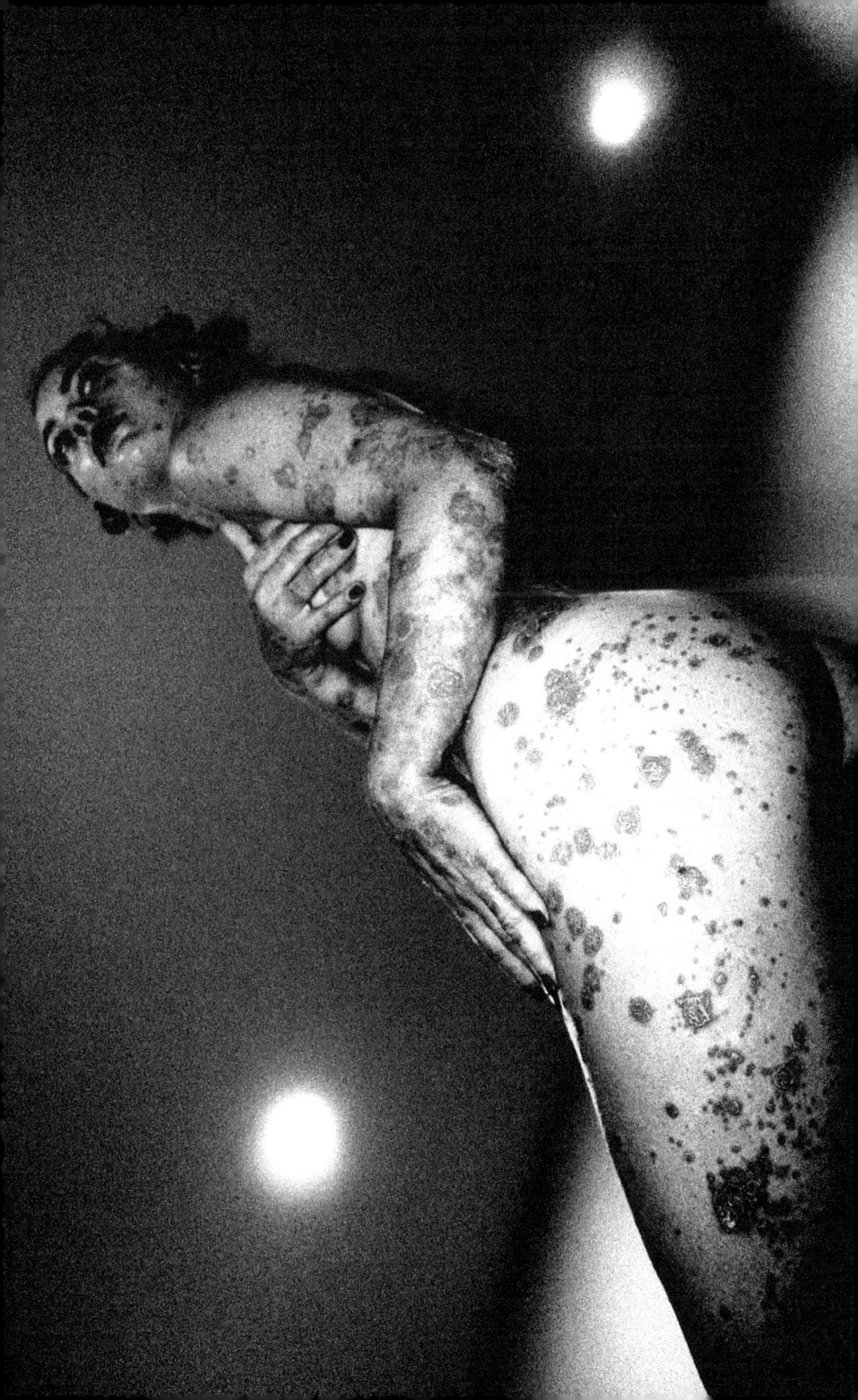

Thailand – The Best and Worst Time of My Life.

I found some passages from a diary I kept while travelling in 2015. I wanted to share these with you…

"I moved to paradise only to experience hell."

18th Jan 2015: Again, I have noticed I am happier and more hopeful when morning has passed. When the trauma of realising my life wears off, I just like to chill by myself and don't go out adventuring like I should be.

It's so beautiful outside, the sun, the sky, the sea… they beckon to me.

But I can't dress myself. My body is so sore. I'm only comfortable wearing very little… and, unfortunately, that makes others around me uncomfortable.

It's not how I want to be spending my time here in Thailand. I can't believe it's back again. Why is the sun not making it better?

I am here to start living a new life, but I need to make this happen for myself, right? I need to be happy.

But, with the way I feel a lot of the time, how do I get there?

I have just remembered a comment Tay made a few weeks back. He said that he can always hear me; I am never quiet. My personality was so large that I made others happy. It's crazy looking back at yourself and how you used to be before life turned upside down and changed you.

This was before my skin got bad… I was a different person.

Why has it silenced me this time?

Why am I feeling unconfident about it?

Maybe because for the first time, I don't know what to expect when it comes to the state of my own skin. It's become so unpredictable that even I'm not sure what my own body is doing.

And this time it started all because of swollen glands!

But this makes explaining it so much more difficult. Some people try to give me cures and remedies, but here's me, still trying to explain I love my skin and it will get better… eternally hopeful, as ever.
But the people here think I am bizarre, with a fake smile plastered on my face. Acting like I'm ok and this is totally normal…

"It's all under control folks, no need to panic. Please resist losing your shit at the mere sight of me. It's just psoriasis. I cannot harm you. Just go back inside your homes and do not despair."
"I appreciate your patience during this time."

All they want to do is help me. But their creams and pills haven't worked, even offered to me free out of pity.

I am a spectacle. It's no joke owning a body like this.

But what else can I say…? I have lived with crazy skin for over a decade and if it was gone for good, what would I do?
I have to tell someone.

We should all be writing about our lives. The irony is, in truth, I'm actually a very private person. But sometimes you have to share it all. You have to know.
It's crazy to live in this pain every day and no one know what's going on. Even my friends and family don't know what I'm really going through. I feel so alone.

All I can do is pick at my skin and cry about it. So far, I've resorted to staying in my hotel room day and night and writing about it. I have to focus on my path; now was supposed to be the time to take my dream seriously and do something about it.

It was hard for me to believe that this was all a plan.
That I was supposed to suffer this much, so I could help other people.

I am a ghost of myself, and my spark of positivity has gone, and this is noticeable to everyone around me.

But here I am still writing about it, which is what I need to do. It took for my skin to become unbearable for me to let it all out again and write about the pain it is causing me. Because I can't bear thinking of anyone else suffering the same.

I know I am not suffering alone, and it kills me to think of others feeling this low.

I really hope one day the world will read my story and see my photos and it have the effect I hope…

To see things differently.

Can I really wait for it all to subside and get better on its own? I can't spend another day locked indoors feeling sorry for myself. Paradise is outside, waiting for me.

7th Feb 2015: I finally sought medical attention today, all thanks to my friend Josh who stayed awake all night to drive me to a random clinic on the back of his moped.

They took one look at my legs and body, and they called me an emergency speedboat ambulance to Koh Samui Hospital.

They didn't even allow time for Josh to get me a phone so I could contact him while I was there. I had nothing and was so alone.

They treated me as an emergency case and, without even being able to say goodbye, I was taken away and put on the boat.

It was just me and two men on this boat, it was pitch black and I had no phone and no idea what was going to happen.

I was just so hugely grateful for the fact I was finally on my way to getting help. Real help.

The lone passenger riding in a medical supply speedboat.

As the water rocked and raped the boat, I remember feeling scared, vulnerable and in so much pain… Every move I made was breaking my skin.

It's been quite hard the last couple of weeks on Koh Phangan, without any family support. I shouldn't have stayed on my own for so long. Why have I put up with so much?

I wish I had someone to talk to… Just to cry.

Finally arriving at the hospital, I showed doctors a glimpse of my skin and calm turned to carnage at the hospital, all rushing round to get a peek. I was quickly seen by the best skin specialist they have. But I felt safe. I felt I was in good hands and would now be treated with the help and expertise I need.

They took me to a room to look at the state of my skin. And before I knew it there were four others surrounding me. All looking at me and speaking Thai amongst themselves.

As I had no money and a time limit drawing ever closer for my free ride back to my island, I was worried these doctors thought it was an all-night show.
When I explained I had about an hour to get back, they rushed to pick me up some ointments.

I was given nine tiny 30-gram tubes of steroid cream.
How the hell was that going to cover my body??

But there was an issue with my insurance.
You see, because my skin had been great in England, I didn't disclose my psoriasis. That's the thing, when it's not in your face, it's not on your mind.

They wanted money I didn't have. I eventually got some wired to me, but I had to leave the hospital and run to the closest money exchange bank.
They told me it was just a straight road, but that I probably wouldn't make it back in time.

I hadn't even been treated yet, and I had to run with 40 minutes to spare before my boat left.

I couldn't believe I was doing this, I was crying and running as fast as I could, but the pain I was in caused me to throw up a few times on the way.
…Charming! As if I didn't look strange enough…

But I had to keep standing and keep running.

I barely had enough money for the creams I needed, let alone another way home.
I got there just in time, and with the doctors and nurses waving me off, I ran again.
And I made it! I made it to the boat. This time in morning's light. It was a very different light indeed.

All I felt was relief, clutching the bag of creams in one hand, as I clutched the boat with the other. I knew they would save me.

And save me they did, for a time.

The thing is, when we heal, we start to itch.

And when psoriasis heals, it itches like a bitch.

The itching, right now, is unbearable. It's taken me an hour to write this page. I'm sure I'll block this day out of my memory eventually. I'm sure I'll block all of this pain away one day.

22nd March 2015: At first, I wasn't bothered by the constant stares and intrigued eyes.

I have learnt to embrace it. It was fun at the beginning.
I was treated like a celebrity. Just because I'm different. They treat me differently to people everywhere else; I can see love and kindness in their eyes.
They don't just stare, they ask questions.

I will do what I can to show this doesn't affect me. And for weeks, that is exactly what I've been doing.

But in no time, I began to find it hard to cope.
I'm barely existing.

Psoriasis has finally got the better of me.
And my happy, positive view of my skin has completely changed.

After another day and my skin growing worse and even more painful, I thought I'd take it into my own hands again and go to every clinic in town.

This was the day everything got serious for me.

When walking into the third and final clinic, the doctor looked at me in disgrace… and I guess that's what was needed for me to be taken seriously once again.
He took photos of my skin and sent them straight over to a doctor at a hospital on another island.

We waited anxiously for around 20 minutes before the doctor called us back. He then told me something I could never have expected.

He told me I need chemotherapy to cure my psoriasis!

He spoke very good English but I still had to make him repeat himself over and over, just to make sure I was hearing it right.
"CHEMOTHERAPY?!" I said to him… "But that's for cancer!"
He said that they have the same vital ingredient that would help heal my skin. I couldn't believe my ears!
Since when is psoriasis as bad as cancer?

But it was killing me. It had already killed the person I was. The Giorgia I knew, is gone.
I have to go back to England.

All I want is to stay on this beautiful island and be happy.

But I have already spent too much of my time here sweeping up outrageous amounts of my own skin… past versions of – me.

Question time: 'As sufferers, do you think we shed more tears, or do we shed more skin?' Sucks, doesn't it?!

I've made my mind up; I have to go home – to save my skin.

I'll turn my life around and make this my power, once again.

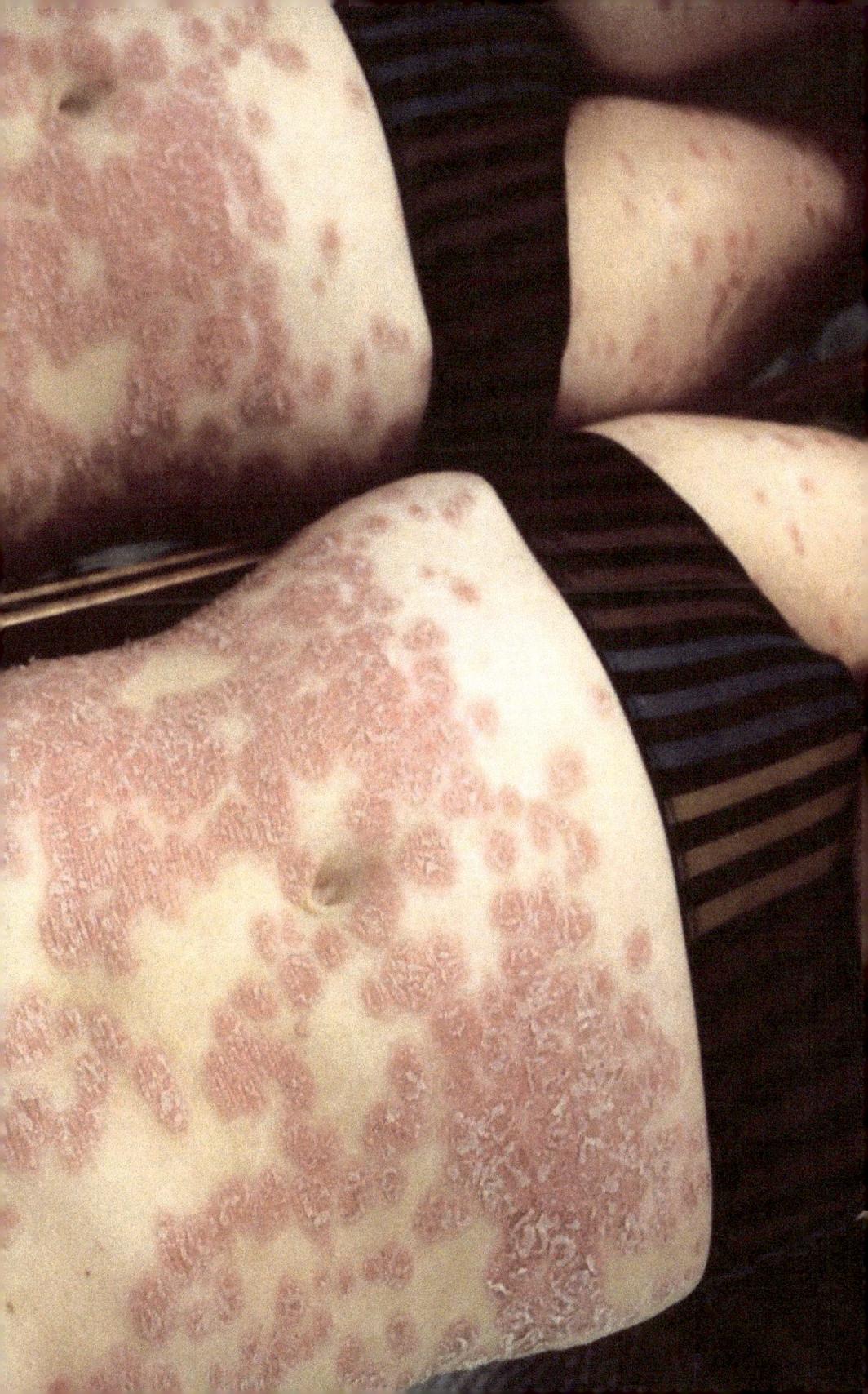

Why I Write

I write because what I have been through is too crazy to keep to myself. Don't you feel like that about your life sometimes?

Can you imagine a world where everyone was happy with themselves? Comfortable in their own skin, instead of trying or wishing to be someone else? Prettier? Skinnier…? *Normal?*

I want to photograph others with insecurities. It helped me turn my pain into my power, and I want to be able to do that for others. It's not just about a good photo. It's about what it does to you. It's about how you choose to see yourself and how you will come to terms with the person you truly are and can be.

I want to show the world that whatever you're insecure or unhappy about, it can be made beautiful, and to show you that your pain *can* and *will* be your strength.

I feel i have a lot of power behind me. The people I have lost over the years have pushed me to want to achieve more. Not the opposite.

I don't know why, but I just feel like my dad is still there, somewhere.
I have to make him proud, still.
That's my power. I know what I want, and I want a world where confidence isn't just *key – it's obvious.*
Being confident in ourselves IS the key to happiness.

This version of you…Are you happy?

It's not fair for you to be unhappy. It's not right for you to dislike who you are. And it's crazy to live your life thinking you're not good enough.
So, snap out of it. You have to!
We have to become stronger mentally if we are going to win this war with ourselves.

I felt like I was fighting for a long time… But I won.
I took back control and found my happy, now I must protect it.
I won't let ME treat ME badly anymore.

Because who's really in control here? Our minds? Maybe not.
Where is this feeling coming from? Once you realise your mind can be manipulated, you start to realise there is more to us than just what our brains tell us to do and feel.
Is it my heart that's telling my mind I'm good enough now? Is it my soul that's convincing my mind I can go further?

We are conditioned to be how we are, right? That's why we simply get used to the lives we lead, even if we are unhappy.
We get so used to the judgement, from all angles. And soon we start to believe the negatives. But just because your mind is telling you they're right. It doesn't mean you are.

You have to tell yourself off, keep yourself in check.
Do not allow that negative brain feed to go too deep.
Who cares where the feeling comes from? But find it.
That voice inside that reminds you that you're a good person.
It's so hard sometimes, we put ourselves down because we KNOW we CAN be better.
We know it's there… we have all the tools we need to change our lives for the better.

Learn to tell your brain to '**fuck off**' when you're putting yourself down. Laugh at the negativity when it pops by and realise it's our own limitations that stop us from doing anything in this world.

If you think it, you can believe it. And when you believe it, it just becomes you.

Why is it so hard to stop caring what they think and tell the world:

"Fuck You!"

That's what you want to do, isn't it? And when you do, it feels immense. Unfortunately for us, life is what you make it. And speaking from many years of experience, sitting on your ass and moaning really isn't the person you want to be.

So, I guess sometimes we must make better choices. Sometimes, the choices we make aren't easy. Sometimes, the person we want to become isn't easy to find right away. And sometimes it takes your full potential to see exactly that.

I guess I always try and find the silver lining in everything – I have to try and make some sense out of all the tragedy we go through. I have to find the good in everything now. I'm done with being negative.

– And that means, looking for the positives in everything.

Over the years I've realised a few good things about having psoriasis. Who would have thunk it, ey?

For example, mosquito who? They don't like my blood and that is a huge plus – trust me. I haven't been bitten by a mosquito in years, even when I spent four months in Thailand. Anyway, I've already got red spots that itch.

I guess the little buggers took one look at my skin and thought "Nah, I'm good!"

Also, any cuts or grazes heal much quicker... Or just create a new patch, so be careful with that double-edged sword.

And I'm not being funny, I know there are a lot of you out there who are 'spot poppers' – I am not.

...But with flakes? *You feel the peel. Instant relief.*

Not only that, but my psoriasis gave me the mentality check I needed. It made me realise how being different is a good thing... And perhaps even something to be admired.

Barely coping with psoriasis also left me with a greater compassion and empathy for others around me. It was somehow easier to see pain in other people's eyes.

And you realise, everyone is going through something.

Everyone is simply trying to be happy in their own way.

And, lastly, my skin became my passion, and without it I wouldn't be here today... doing just this.

My dad died suddenly, and my psoriasis appeared suddenly… The grief I thought was contained in my young mind, was actually venting all over my body.

Or at least that's how I understood it, and that's what I told myself… over and over – and although my pain kept growing, and my poor skin changing rapidly, becoming more suffocating by the hour… I knew, deep down, I had to change my mental state first – in order to fix what was happening to me.

I couldn't let it rule my body in this way. I had to see the good.

It was hard for me, not being able to call my dad and tell him about my new skin. Not being able to get his support or know what he would say…

But eventually, I did start talking to my dad again… I would cry and talk to him as if he was still with me. I would tell him how I felt and how much I was hurting. Waiting patiently for a sign, any sign. But the silence echoed. The responses I felt made me feel stronger, but they didn't come from him… They came from me… "You'll be ok, Giorgia."

My skin only flared up when I was unhappy… So, I knew what I had to do. I HAD to be happy… Forever! LOL right?!

Forcing myself to change my perspectives and find happiness, while grieving, was not easy.

By photographing it – I found the beauty in something I thought was so ugly. I started seeing myself as art instead of pain – and completely changed the way I thought about myself. I knew I had to share my pictures and help others suffering like I was. Seeing my photos was so overwhelming. And all of a sudden it was clear.

That was it! That was my path in life – I had found the reason.

…And I've felt that way since I was 13 years old.

It's now been 20 years without him. And if my dad's passing was going to leave me with psoriasis, I **KNEW** I had to turn it into a good thing.

We are in the era of mental health domination. Now is the time to prove to yourself that you can do it. You've heard of 'The Law of Attraction' right? Otherwise known as 'Constructive Interference' in physics. It's all about the energy you put out into the world.

Being negative will always bring negativity to your life. Fact.

I just want to help rid some of the darkness in this world. And start to see a world where everyone is happy with who they are.

It's taken me that long to get to this place. It is hard, if it were easy, everyone would be euphoric.

Every day, when I looked in the mirror, I would force myself to snap out of it and stop crying – and, instead, would give myself a compliment.

Every day, when I walked down the street on my way to work, I would force myself to stop thinking negatively – and, instead, remind myself of my potential and smile.

But unfortunately, I haven't always had this mentality. And in life, we can be strong, and we can be weak. I struggled not just with my skin, but my attitude towards life. Psoriasis sufferers know the discomfort that fills each day and when I didn't want to feel that pain, I would drink, and smoke weed… until I didn't. They were the only things helping me through it.

But it's a little like putting a Band-Aid on a bullet hole.

I was still grieving heavily at 18 and admittedly found ways to cope that 'Dear Old Doc' wouldn't approve of.

I wanted to live and enjoy my life on the outside because inside, I was desperately damaged.

I knew psoriasis was incurable and the severity of mine threw me into a state of shock. Was I going to feel like this forever??

I wanted to make myself happy any way I could back then.

I wish I could have found my strength earlier – because it's *so* powerful when we do.

I remember getting ready to go out as a teen. I would wake up sore and dry; my mornings consisted of me scratching, peeling, and picking, while crying.

I would put my make-up on, while crying. I would cream up my body from head to toe, while crying. I would look for comfy clothes to wear, while crying.

Then finally I would look in the mirror, and that's when I would see who I was.

My make-up didn't cover it. My creams became my enemy; it had dried before I'd even clothed myself. And my clothes weren't comfy at all… They only made sure I couldn't forget.

Every time I looked in a mirror, it wasn't my face, clothes, or skin I saw. It was just my eyes. Filled with tears and pain.

And every time I looked into them, I felt defeated.

It's not easy to remember or recall life, is it?

I used to have a love-hate thing with my memory – or lack thereof.

That's another reason I like to write. I learnt early on it was a necessary benefit: to write how I felt and photograph how I looked.

I had to remember this part of my life.

The good, the bad and the ugly. A side that for a long time was completely masked.

And I've been doing that for so long.

So, what do I do with all these words and pictures?

Sharing it all was an inevitability when I think about it. Mum passed it down to me. So, what happens if my daughter steals my genes as a teen? As I did from my mum.

I'll have to teach her everything I've learnt. I'll show her my pictures… pictures of her mummy… pictures that helped stop people feeling alone in a world full of judgement.

…The pictures that made me feel happy again when I was in a sad world, all of my own. And the words that meant so much to me along the way.

Somewhere I saw Miles Davis was quoted saying: "If you play a wrong note, play it loud and everyone will think you played it on purpose."

This is me, so I had better smile and act like it's all good.

I would have made a great actor. Because, honestly, faking that first smile is how I got to this point today.

It's ok to mess up. We all do.

I feel like I grew up too quick mentally, but physically I was like Peter Pan, not wanting to change or grow.

I was young, rebelling and having fun. Or at least trying.

The difference is, now I'm actually a grown-up.

And all we have left is the mentality we've built over the years.

I will never get over the fact my dad died.

I will never get over him. So, my psoriasis will always be here.

But now when I look in the mirror, I see happy eyes in front of me.

…When I get over the immediate reaction to my skin of course. Shocked eyes first, then happy eyes.

You see, it's not about what's on your face or your skin. It's about what you see inside yourself.

I see myself for who I am now.

I can be happy, and I can rule this body I was given. As long as I stay strong and believe in myself.

I respect myself and my choices now. I know what I have to do when I look in the mirror. I know the person I want to be.

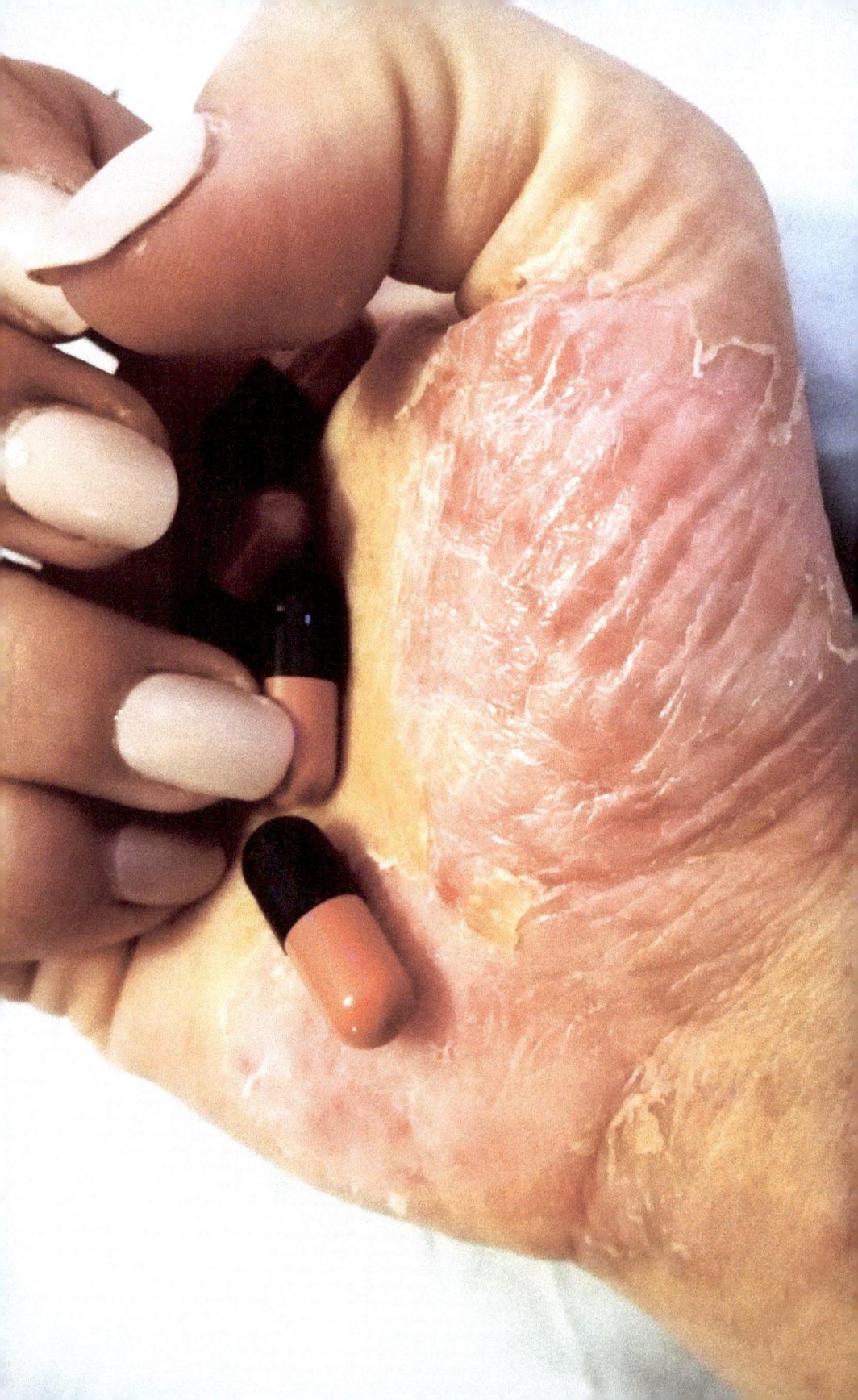

Medication

By the time I was 28, I had refused any and all medications doctors pleaded with me to take… for years, I said NO!

I had control of my skin and, more importantly, who I was. I only used creams and ointments, for 15 years.

…. And positivity of course. It appeared and eased like clockwork. I was in control of my mind and, so, my skin too.

And it would come and go, depending on my fragile mind at the time.

I was in love with my reoccurring leopard spots and found true confidence by owning it, photographing it, and eventually sharing my photos to the world after my Thailand trip. I had found my calling in life and all I wanted to do was show everyone and help others find the same confidence in themselves.

But after 2019, it all changed. I lost all three of my remaining grandparents to Alzheimer's and dementia. And on top of all that… my best friend George passed away, after a long and brutal fight with cancer.

This was unreal. How could this happen? Why?!

Maybe they saw Covid coming and decided to check out before the world went into crisis?

I knew, as much as I was suffering, it wasn't just me. My amazing mum lost both her parents, within a three-month gap.

My skin became so severe and more painful, itchier than ever before. Every day, covering my body more and more.

With grief and stress as my triggers, it caused my psoriasis to explode like nothing I'd ever seen before… on anyone. I mean geez, I thought I had seen the worst of it.

It became unpredictable. I had already lived with trying to hide myself, and admittedly I was so stupid to let it get as bad as it did. But I waited and waited in hope for it to ease up – like it always did before.

Almost a year passed, and it just got worse and worse.

I was crippled by it. Really, the dry patches meant I couldn't stand up straight. I couldn't sit comfortably. And when I was, being comfortable meant picking at the patches covering my body. My scaley silver linings.

I was a shell of a person, not able to walk or sleep.
But the cut-off for me was that I couldn't even cuddle my beautiful baby girl. I couldn't put my arms around her.
She was just one, tiny and cute and wanting her mum.

SO, ENOUGH WAS ENOUGH!!

I HAD to accept help and give in to medication.
I had to save myself, for my daughter's sake.
I was in utter turmoil, crying to my mum, telling her I hated this decision, because it went against everything I stood for. I had been fighting for years, willing others to find happiness, instead of medication.

But this time, my mind wasn't strong enough to help me get through it. I had no choice, trust me.
I hope you can all understand and not judge me for it.
Because of the severity of my skin and mental health, I was fast-tracked to see a specialist at Basingstoke Hospital.

On the day, the specialist asked me to be patient, as she called in seven different doctors and medical students to look at me.

'Welcome to the freak show'… I must have a knack, to be able to shock people so regularly, just with how I live.
I feel like I should be charging entry fees at this rate.

But I stood there… practically naked and in tears.

It was so hard to see their faces and professionally stifled reactions, due to my presence.

But poker-face or not, they were utterly shocked at the state of me and asked if they could take pictures to be used in future medical journals.

I agreed, and when I got dressed, I awaited my fate as they discussed what treatments would impact my skin the most.

All of that time, I was scared shitless about putting something in my body to fight my psoriasis… The very thing that makes me unique.

Before that, I had learnt to wear my psoriasis like a badge of honour. And I was scared of it being stripped away.

When I pulled back the curtain, thankfully, only one doctor remained. She asked to escort me to a separate room, where she proceeded to sit me down and explain that my arm had to be wrapped in zinc bandages right away.

I had been scratching so much over the previous nights, that my left arm resembled third-degree burns.

It had to be wrapped NOW.

My arm was bandaged for weeks, but the zinc helped massively. I could no longer tear my skin off with the pain. I had relinquished control and was forced to allow the zinc to work its magic. And magic it was.

When I went back to have the bandages removed, the pure relief I felt was soon overshadowed by the doctor induced pressure to choose and start medication.

It was time to decide. Perhaps my dermatology specialist was growing tired with me. She was watching me struggle so ridiculously with pain and yet didn't understand why I was refusing to accept help.

But it wasn't the help I was refusing; it was the medication. I thought I could fix this on my own.

But I couldn't, and that broke me.

I needed to do it for my daughter as clearly, I couldn't fix up and look sharp in time. I had to give in and accept that my skin wasn't on my side anymore.

I knew my dad would have been screaming at me to just 'GET HELP GIORGIA!'

Perhaps I had gone too deep to expect my strong will and mentality to heal my skin again. I had done it before, but this time, I just couldn't turn it around and make myself happy.

When my doctor handed me a leaflet on Kyntheum, all I focused on was the side effects. Like most of us do. We worry about what it might do to us, but also, what do we have to sacrifice to make sure our bodies are kept stable during treatment? What will I have to give up?

Luckily, Kyntheum has very few, and after many blood tests to make sure I could actually take it, I was given my first injection.

I couldn't believe it, after just one week my skin was changing. I was so shocked at how quickly it was working for me... And so were the doctors.

It calmed almost immediately, and within a fortnight my psoriasis started to disappear.

My skin was better. But inside I was absolutely gutted.

I didn't want to be in pain anymore and I was so grateful that I wasn't... But I was scared about who I was now. I had no dreams of being this girl.

I was no longer the girl with psoriasis. It was gone.

I haven't had clear skin since 2003, when I was just 12 years old.

But all I could think about was the fact that I couldn't take photos of my skin anymore.

I stopped doing my photography because I hated looking normal. I got no likes as this girl. And that made me feel even worse.

I was now scared to be judged for having good skin.

My head was in bits, fighting with my identity.

Who am I supposed to be?

I had no backup plan! Gaining psoriasis after losing my dad is the reason it means so much to me. How could I share my psoriasis story if it ends with me taking medication to get rid of it?

That's when I realised, I had to change my path.

I had to become mentally strong in other ways. Not just focused on my skin.
I had learnt the power to love myself *with* my psoriasis.
Now, I needed to learn to love what I was doing *without* it.
My path and dream of photographing my psoriasis was over.

But as we all know 'miracle treatments' can leave us damaged in other ways.
With any biologic treatment, it can and will affect your immune system. As is the point, I guess.
However, if I could… would I make that decision again?

The treatment left me with a weakened immune system, leaving me to fight off more sicknesses and bugs than I'd ever experienced before.
Not only that, but when I started the meds, I got a new allergy. I've never been allergic to anything in my whole life.

And "BOOM!" said her face.
"Oh, that's excellent," she sneered sarcastically.

I wasn't prepared for this, I thought medication would make me stronger, not weaker.
So, what do we do when we find ourselves being beaten by the world again?

I thought it was all over for me. I had been telling people for years, don't give in to medication, you can beat this on your own. But if you can't, that's ok.
I know that now.

But the grass isn't always greener, baby.
And you should know that.

In 2015, when I shared my photos, I realised just how niche my advice is. And social media has allowed drug pushers to be magnets for desperate bodies.

Convincing us of miracle cures that don't exist. And instead of learning to be happy and love ourselves, we are often manipulated into taking medications that only cause other issues.

After a while I stopped posting, it was hard for me to be a voice for others when there were so many replying before I could, with remedies I didn't agree with. I wanted to give support and change perspectives. I didn't expect my followers to be picked on to do the opposite, posting different medications for seemingly easier relief.

I received messages from sufferers all over the world.
It broke me, reading your stories and knowing about your struggles.
I'm so sorry for those I wasn't able to reply to.

It made me realise, I don't want fame. But I do want fortune.

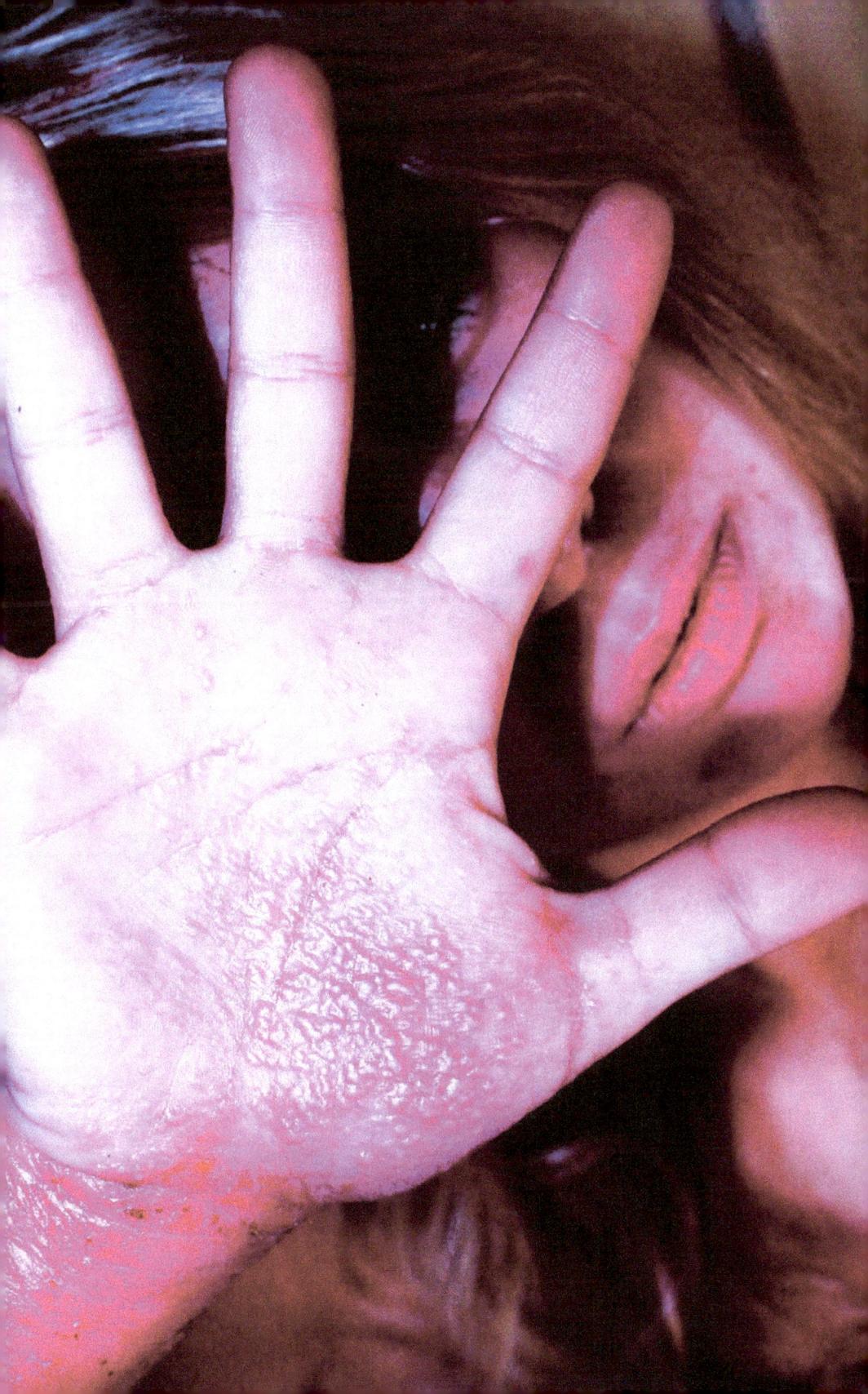

The New Me

I found an old diary today; with some artwork I had done during my weaker moments – all with hidden messages to myself.

You see, I love art – as do so many of us. For me, I guess that's where the crazy gets out.

There seems to be a pattern in my artwork.

And it's always me trying to wake myself up.

The lines in my art, telling me to get up now and change my life. Make it happen.

The weird thing is, why, on that particular day, did I not, in fact, make it happen? Why didn't I start then?

I seemed pretty certain of myself.

So why did I doodle it with my fancy chalks, instead of actually get up off my ass and *do* instead of just *chalk*?!

I would have added some to show you… But let's face it, this art is way better.

The fact is, I wasn't happy then. The drawings were simply a reminder of a strong mind in a sad body.

Drawing when my skin, or anything, gets me down is one of my favourite ways to cope now. It helps to release some of the heartache, instead of keeping it in. but I don't like to share too much …*she says*.

It's about remembering you are unstoppable.

So, remind yourself of that strength, wherever you find it, and remember… Nothing can stop you.

Nothing should be able to stop you.

You are the one that pulled yourself up over and over again. And it's when we are at our absolute lowest and life is falling apart that we finally have to look for the light.

Look deep inside and think about what we want.

It all started with a thought. And for so long, thoughts about my future were all I had.

But you can eventually become what you think, and this is because thoughts lead to actions, actions lead to habits and habits lead to lifestyle.

It's only when you finally put the actions with the thoughts that change can happen.

It can't all be about hope. We have to make it happen.

We are all depressed occasionally, no matter where you are in the world – what stage in life. We all feel it.

Whether we are diagnosed or not… This is planet earth and, unfortunately, it goes with the territory.

We have to stop holding ourselves back and being addicted to this negativity. This world that is only bad if we choose to look at it that way.

What's stopping us from being truly happy?

I tell you, appreciating the birds, the trees, the breeze and the grass beneath your feet is a good place to start.

We have to learn to really enjoy the little things.

And just appreciate who we are!

Is it possible that we're too attached to the person we've been? And this is stopping us from becoming who we want to be?

I know it was true for me. I was getting used to the person I was, with forever changing different skin and happy to go through life as that same G.

I'm a good person. That much I knew, but I had to be prepared to let myself go a little, the old self – if I was ever going to make changes and get anywhere in life. I needed to start pushing myself.

I had to stop being the martyr in my own story and focus on how strong it's all made me.

I think I was just great at self-sabotage.

It sucks, doesn't it? We are so good at it, that eventually we can build up trust issues with ourselves.

Luckily, I'm over the worst of it. But it does affect me more than I would like to admit. For example, do you ever lock your car and walk towards your home, only to run back to your car to check it's definitely locked?!

– I know it is! I just did it, so why am I checking again?

And maybe that other sock 'didn't' go in the washing machine at all – because I didn't check or look for the pair.

Or the Tupperware debacle. Maybe they are the right lids, but I was lazy and accidentally warped them in the dishwasher?

Also, why is it that I sometimes love reality TV, and sometimes can't stand it? It's nice to watch other people's lives, but the second they start bitching… I'M OUT.

In all honesty, I used to fill my gaps and spare time watching any old crap – subconsciously trying to avoid my life, I guess. The gaps in life that are now spent working, thinking and breathing my passion.

Now I'm doing that… I can't bear to sit still for too long, every gap I have is spent working on me, filled with thoughts of my future. And how I'm going to get there.

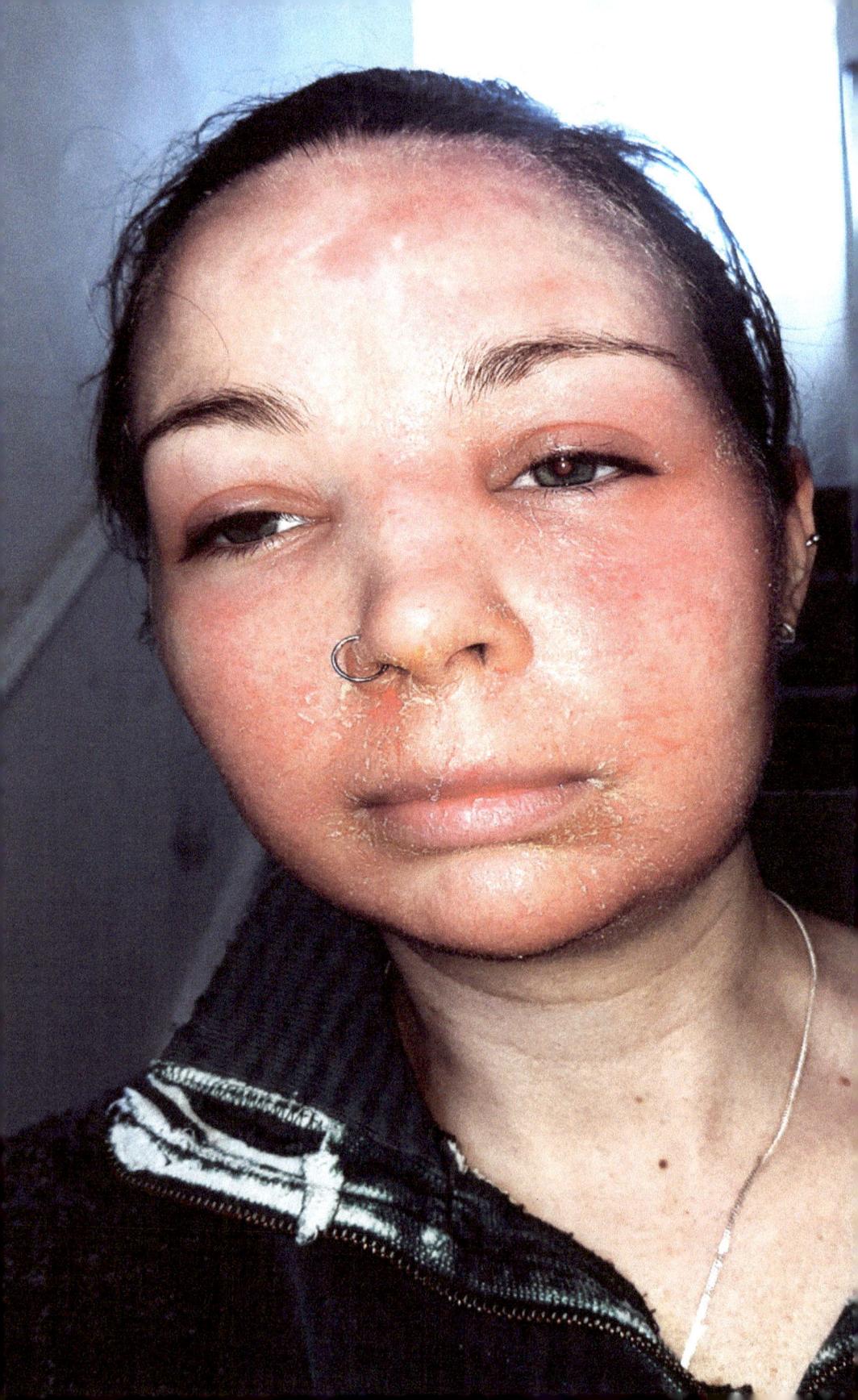

Judgement

Trust me, looking like this is no picture.

No matter how long it lasts. You start judging yourself even before others get the chance.

It's hard to be understanding of something you can't understand yourself.

That's just it though, when we don't feel ourselves, we start to acquire that fantastic little feeling of 'self-hate'… and that's the problem.

What a horrible feeling. We should never feel like this…

No matter how we look.

I'm a strong person, but bloody hell. How do you imagine I felt seeing a different face staring back at me every day, not knowing what it was or when it would ease up?

But really, what hit me the most with this new reflection… was that it's never going to stop for me.

Psoriasis or not – I will always have different skin.

It's not easy to see yourself in a positive light all of the time. We don't always see what we want when we look at ourselves. But we should, whether we have bad skin or not.

We have to stop judging ourselves.

I knew it wasn't ok for me to cry at my own reflection anymore – but it was deeper than that. I couldn't just make the choice *not* to cry; I had to completely change what I thought of myself. I had to change my instant reaction, or I would always feel this weak.

So, I gathered I can either choose to cry and pity myself or I can make myself proud and learn to love the face staring back at me.

I had to change the way my mind was working, or I would spend the rest of my life suffering – not just physically, but mentally.

With psoriasis, it was obvious to me that the more positive things I told myself, the more my skin would clear.

With this new, still-undiagnosed allergy, I have no idea what to expect, how to treat it, or how to cope.

We know it's a Catch 22 with any stress-related conditions… the more we stress, the more it affects us.

It's a vicious cycle – that needs to be broken.

But allergies are a different ball game altogether. To me, it was just another sign from my dad that this is what I'm supposed to be doing – but no more skin conditions please, I think I've got enough content.

I couldn't imagine watching my daughter go through any of the pain and heartache I have.

And with that thought, I would like to thank my mum for all of her support… To watch your child grieve, be depressed and at their absolute lowest, can't be easy.

So many of us right now are feeling that pain every day. No matter what we suffer with, we can't let it rule us. Pain changes us, in all matter of ways, but we feel who we are in our darkest times.

Perhaps our most authentic self comes out during our hard times.

Our weakest moments… It's a time when we let our emotions get the better of us; we are completely honest because that's when we finally stop trying to be strong.

It is ok for us to feel strongly sometimes and crawl into that ball on occasion. But it's how we pick ourselves up.

We must recover the right way when things go wrong.

One of the biggest problems we have in this life is that we are constantly judging ourselves and others.

It's hurtful to give an unnecessary negative opinion.

So why is the world full of it?

Social media has made it easy for us to criticise people we don't even know. That's a human trait I think we could all live without, no?

That is what I would call massive 'Human Error'.

It's such a huge problem that just makes me fear for our kids' future.

"We have to think of the children!"
"Please! Think of the children!"

When we are judged it hits us hard. But what happens when you realise the people judging you have created their own versions of this life, from opinions based on their particular history and emotions? If opinions were based on fact, we would all share the same ones, right?

But our own struggles mean we veer or sway differently. So be careful of who you listen to. And know that even if you respect them, you may not respect their opinions. Or need their advice – that doesn't make us enemies.

We have to be smart enough to ask for advice but wise enough to know who to seek it from.

Every decision you make shapes an outcome in your life. Make it a good one.

Where do you want to be?
I'm an over-thinker. And it's been the bane of my life.

I remember for far too much of my life, I hated being left with my own thoughts. Silence scared me. And trying to sleep scared me, because when I was alone and thinking… I was in trouble.

I put so much pressure on myself that every solitary thought was me reminding myself of my dreams, and instantly blaming myself for not yet achieving them.

When I did get to sleep, I found my dreams were always better than my reality and that's all I wanted to do.

But it sucked me into a world that wasn't real.

Uncertain outcomes can lead us to feel life is not going our way. Because, truth be told, you never know what is going on inside somebody else's head.

How many people have I met when I was in a bad mood? That mood that just gets us.

"Boom!" You got judged!

Isn't that madness… when you think about it?

But it's not just about what others think of us... is it?

How do we get rid of our internal critic, constantly telling us "we're not good enough"?

I'm working so hard, bringing in a bloody decent wage for someone my age and still struggling to pay for the enjoyment that is 'living'.

We can work as hard as we like, or not. It all depends on if we are passionate about the work that we do... am I right?!

Because if we don't enjoy the work we do every day, we internalise so much more negativity.

Have you ever woken up, thinking 'FUCK, FUCK, FUCK' while getting up for a job you hate, but endure... for what?

Are you like me? Judging yourself every day for not being where you want to be. Where you thought you would be?

I'm only 32! That's so young. So why on earth does the pressure creep in on us so much?

I had better listen to it and act, otherwise I'll feel like this until I'm old and grey, with nothing left, except regrets.

The only way I relieved myself of this lifelong battle, was finally finding and working on something I love. Oh, and I manifest now, instead of blame. What I don't have yet, I'm putting out into the world – and now silence is golden. Because I'm happily focusing on my future in those moments.

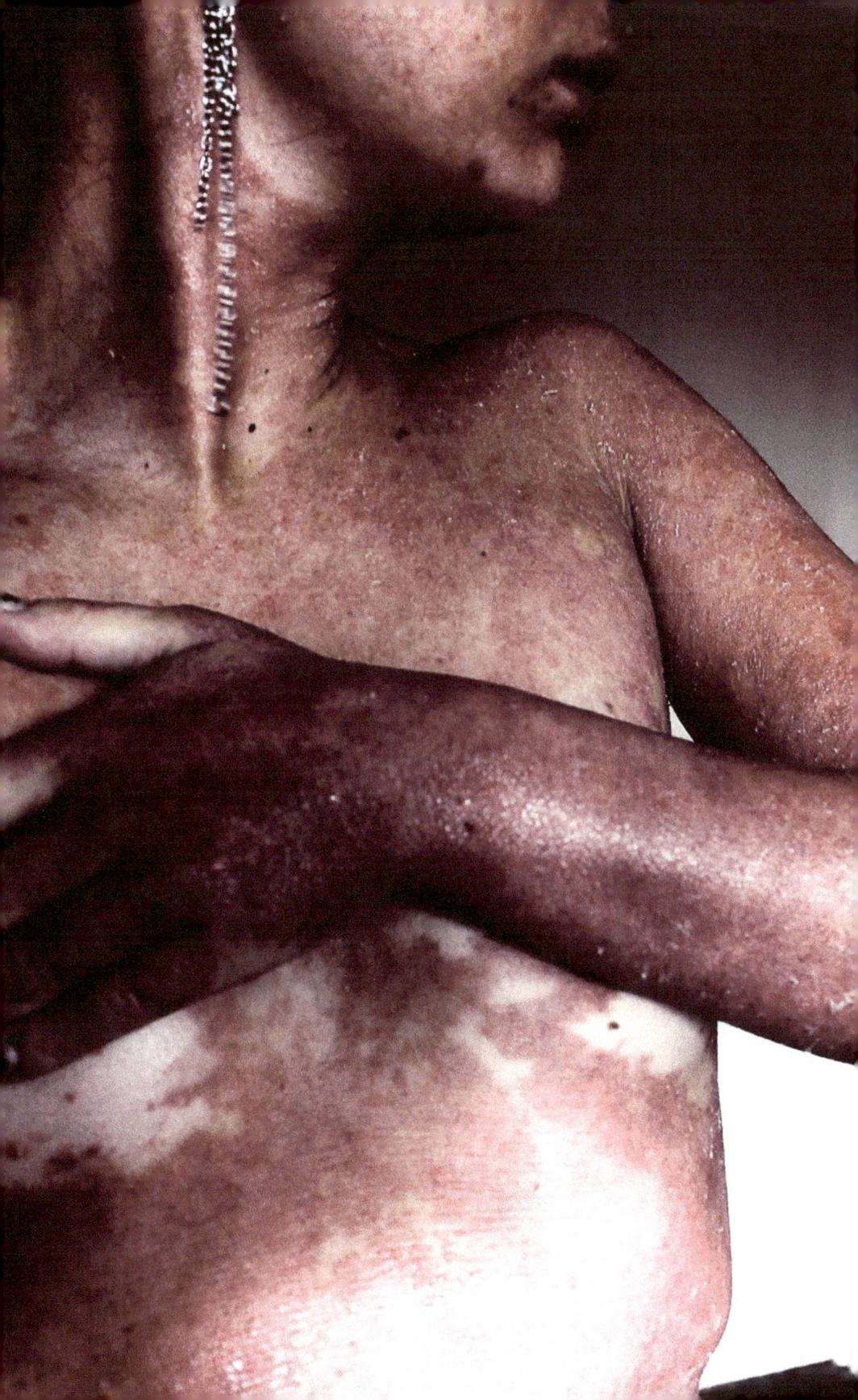

Pressure

Are you living the life you want right now?

Or are you just like I was? Totally consumed by fears and insecurities about the future. We want so much for our wishes and dreams to come true... for our futures to be bright and beautiful...

But instead of focusing on what we can achieve, we kill ourselves with worry over the pressure every single day, and it's brutal!

I have spent my life dreaming and wanting to be successful. Wanting more, feeling so much weight on my shoulders to make them all proud. To become the person, I want.

So why am I constantly letting Procrastinating Pete get in my way?

We have to stop complaining, waiting, worrying, comparing, and wishing for a life we believe is out of our reach.

I spent so many years tormenting myself with the pressure of a future I wanted, with no clue of where to start.

I don't want the person I am to stop me becoming the person I want to be.

It can be hard to stop stressing about what's next and learning to stop and smell the roses.

One way I took control of the 'Future Fear' is starting my day with a few simple reminders. Reminding myself of what I'm capable of. And who I can be.

Because, when life and stress are overwhelming us... it can paralyse us mentally.

– With the end result being no bloody change at all.

Because stress without relief builds up inside, causing us to sink into feelings of inadequacy and hopelessness. Have gratitude for what you have. And what you've achieved... so far.

Claim a different title for yourself.

Live in the present and accept what is because some things you can't change in an instant.

So, look for the good instead of focusing on the bad.

We should all have created our 'Bucket Lists' by now.

But your last bit of homework should have been to create a Mentality Bucket List – also known as a Life Audit.

And it all comes down to this:

Do what makes you happy.

And if you aren't happy, CHANGE IT!

If you're not happy in your job, CHANGE IT.

If your relationship is toxic, CHANGE IT.

If your home doesn't cut it, CHANGE IT.

If your kids are driving you crazy…. OH BUGGER!!

Get your notepad out. I can wait.

Give it a great name to inspire you. Steer clear of 'To Do List' – reading that gives no one a boner.

Next, figure out and write down which areas of your life need adjusting (career, finances, relationships, health, environment, or personal development).

If you've listed those and discovered you want to change them all, you can and good luck! I'm here for it.

But what is achievable and realistic here?

You can start by choosing the ones that would make the biggest impact on your life and wellbeing. Or you can focus on the little wins for now. The small tasks that nag at you daily.

Once you've done this you will have a clearer vision and sense of purpose. Every day will become so much lighter.

You'll be able to deal with the pressures of life much easier, knowing what they are and navigating your way to solutions – seeing the bigger picture.

Big changes are scary, but they are up to us to create. Because it's much better than staying in this rut.

We are all control freaks, but taking yourself out of your comfort zone is how we learn the most. These are the moments you remember forever.

Soon your head will sync with your heart; you'll become stronger and realise your worth.

The harsh truth is, sometimes even the people in our lives can be bringing us down or holding us back. For example, if you hang out with friends who are negative, you will never see the positives which will limit your

progression. However, if you surround yourself with positive people, you start to attract positivity.

The same goes for who you sit with at work. Studies have been done on it, and it's fascinating.

– Statistics show that if at work you sit close to a top performer, your own performance increases by 15%.

On the flip side, if you sit close to a poor performer or slacker (Otherwise known as your buddy) statistically this can cause your performance to suffer by as much as 30%.

Savage ay!

However, I guess that doesn't change the fact it's not easy to cut toxic people out – that is, until you're left with no choice.

As painful as it is to step away from a friend, and even family… If your mental health benefits, you might have to do it.

Sometimes, your job is easy, or the work is fun. Perhaps you've stayed at your job because of your colleagues. And allowed these to be excuses to submit to the man, be overworked and underpaid.

We are all guilty of it. Putting up with working ourselves into the ground, and still living paycheque to paycheque.

– It's soul-destroying!

I saw a funny meme today. It was a block of cheese going in for an interview… but the boss was a cheese grater.

And when you think about it… that is some powerful cheese. I mean *powerful message*.

We need to aim higher in this life! …And there it is again…
Pressure.
Always coming back to bite us in the ass!

It's a big weight growing up and realising we are each in control of our own ride in this world, and it's up to us to steer in the right direction – unless of course maybe you've just broken your leg and are temporarily being pushed around in a wheelchair… you lucky bastard!

Even a day of relief from the burden that is the Future Fear!

To be incapacitated for an hour. Taken away from pressure. Have no power to be in control of it all – that isn't really what you want to wish for is it?

So, we have to deal.

Your mindset is what sets the tone for everything in your life, and we have to start there.

It's daunting to want more from yourself but know your worth and go for what you want. Go for what will make you happy.

Don't let this anxiety get in your way anymore.

It can be managed, I promise. You can come out the other side with a strong head on your shoulders. Learn to be positive. And you'll have no fear of the panic coming back.

Life is just so short.

Don't buy into the hype that something is wrong with you.

It's all lies.

There is nothing wrong with you. We all have flaws. And when we acknowledge them, we begin to free ourselves of the self-doubt. Making overcoming them a hell of a lot easier.

In 10 or 20 years, you'll be looking back at this version of you, you'll wish to be back here, now.

You'll wish to be younger; you'll wish for more freedom. And you'll wish for more time. The time that is staring you in the face, right now.

So do something amazing.

We've always wondered "Why are we here?"

Maybe it's simply to become the best versions of ourselves and to help others do the same. To make the world a better place by helping the people in it.

We only use a small percentage of our brains, what if we were able to unlock more and be truly at one and happy?

We are evolving, we are believing in ourselves more and more, and we are learning to use the world's energy to our benefit. This is no joke – we are learning to control our own lives. Maybe that's why we are here. To learn how to be this new age of human.

Manifesting and making life happen for us, not to us.

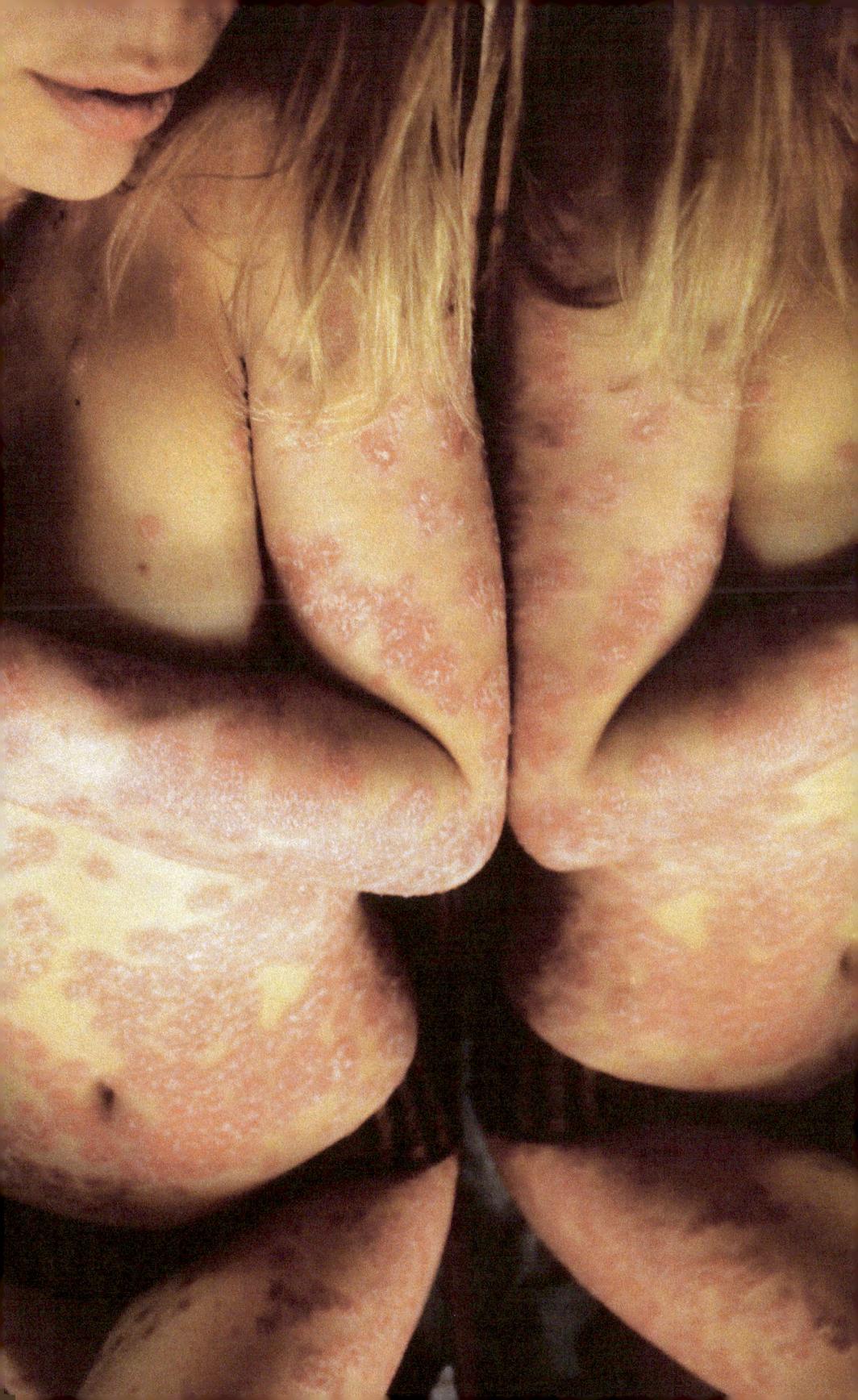

Ambition

I was just trying to imagine a world where we didn't have to work for a living. Try and imagine for a second… What if every day was a Saturday, and we had an amount paid to us each month, for simply surviving?

And then I thought about how I would spend each day if I didn't have to work.

Well, let's see…

Guaranteed I would probably sleep in until noon, eat like a horse and likely see friends and family… Or stay the hermit I am, and just do the first two.

The thing is, I've been unemployed… and it's pretty similar. But having experienced unemployment already, I know the feelings that cloud you during that period in your life. Feelings of inadequacy and, of course, mind-numbing boredom… and that's only when the TV doesn't cut it.

So, what do we think would happen if we actually had the freedom to live like this…? Because I know I would still be feeling the pressure and dreaming of more.

I know I would eventually want to break free of the boredom and start working… Right? I know I'm not alone here.

The difference is the work we would choose to do. Choose? What is that? I get the feeling instead of making the choice that could benefit us, we would stay crippled by indecision.

…And that's where we are currently. Crippled with the fear of failing, and too clouded to see the path that could take us further.

Are you paralysed by so much uncertainty that you end up choosing to stay in a life you don't like?!

The thing is freedom and ambition go together quite nicely. But we don't always have that freedom. So, it's up to us to choose to be ambitious and find the path outside of our boring day-to-day lives.

It's great to have that freedom, of course… but it's just another feeling that tends to make us nervous.

We are constantly wondering, "Am I doing the right thing?"

So, even if we didn't *have* to work, I'm sure most of us would still choose to. We would choose to follow our dreams, right? Work for ourselves and make ourselves rich instead of working for 'The Man'.

Who said we have to stick to it and keep working for someone else, just to survive? But the reality is, our dreams don't survive… they die the older we get.

And we are left feeling like maybe it is just an unreachable dream after all.

I don't want to live with regret.

We are being worn down. We live our lives for someone else. 40 hours a week, devoted to someone else's cause – living someone else's dream – but why we can't seem to find the time to devote to ourselves?

Can we really just give it all up? And try and get what we want?

So, I'll tell you my reality…

In 2023, I was working with a great company, great pay and slaving almost 40 hours a week doing what I do best. Sales… Or so I thought.

However, what happened next changed my life forever.

In a meeting with my boss about my progress, I was saddened and frankly a little shocked to find out that our targets weren't being hit, and although the outcome wasn't a bad one… I wasn't getting any commission, again.

I felt so deflated, something changed after that meeting. Something inside me switched, and instead of thinking "I'll show them", I felt insecure about my work and the job I was doing. Not a good place to be, when you work in sales.

A negative mindset hit me so quick I couldn't believe how I was feeling. It crept in when my guard was down.

I was now unhappy from 9–5.

The thing is, what was a small meeting perhaps intended to inspire me to work harder or keep going, in fact, did the opposite.

When they questioned my abilities, I began to question my own.

All of a sudden, I questioned everything I was doing and if I was doing it correctly.

Although unintentionally, they had made me feel bad about my job. And this was not a feeling I was used to.

In that moment I realised I was wasted in that role.

Doing the work I was trained to because I had to. Not because I wanted to. There is more to me, and they clearly couldn't see it. And I was buggered if I was going to stay in a job that I no longer felt happy in.

Yes, I can do better, but not here, not in this role.

A week passed, and I knew I couldn't spend another day feeling that way.

I knew I couldn't spend another hour unsure of myself.

And then it hit me… and I knew exactly what I had to do.

I had to think of myself; I had to decide what would truly make me happy.

I WAS GOING TO QUIT MY JOB & FOLLOW MY DREAM!

How many of us have actually done that…? Just to try?

Epictetus said:

"You can't always control what's happening to you, BUT you can control how you respond to it."

In my case, I responded, and I took back control.

I guess another thing I should have mentioned, is that a week before the meeting with my boss, I found out I was pregnant with my second baby! A surprise that was… well, a surprise!

My partner and I were both completely over the moon. Telling him was one of the happiest moments in my life.

The thing is, he wasn't sure if we would be able to conceive naturally. He would make jokes to me about it, but I knew, deep down, how much he wanted a family.

So, you can imagine the euphoria at our finding out his swimmers were in fact, swimming laps. I guess finding this out is an incredibly proud day for any man.

My home life was a happy one, so why was my work life the opposite?

I have to say, an impending time limit on the freedom you have is quite a hard pill to swallow. But that news made everything clear to me.

I had to step up.

This pregnancy forced me to quit smoking, quit drinking, quit my psoriasis medication – and quit my job! All these things would make me a better person, if I looked at it the right way.

There was no uncertainty in my mind about what my next role would be.

It was now MY time.

Limited as it is. I must try and fulfil my dream while I can… Right? So… I gave myself nine months.

We all know that if we want to achieve something, we have to devote all of our time to it.

So that was it… My decision was made, and I couldn't wait to tell my boss.

My head was already swayed to the prospect of having no job sucking up this precious time of mine – until our gorgeous new baby makes it into the world.

And instead, I would focus on THIS! Finishing this book.

Good or Bad. I HAVE to try.

Of course, in my mind, I thought I would be able to spend the same 40 hours a week on my book as I did in my job.

But what if it doesn't happen? And my almighty intent on succeeding; is overshadowed and squandered on the sofa with lazy unemployment days? Binge-watching my favourite programmes and being a vegetable – probably resembling mashed potato within the second week – just like the life I once lived… and, let's face it, loved.

But I knew that wasn't me anymore, I've come a long way.

You see, the struggle is real. The struggle to find and make the right decision, daily, is what stresses us out.

I know what you're thinking. Why couldn't you do both?

I'm sure some people are that strong and really do work on their ambitions outside of work hours. And achieve success in both. And to them, "I Salute You!" …Incredible people.

But every hour I wasn't working, every weekend, was spent with my family, playing with my girl, eating well, having experiences, and making memories – as much as I could afford to, anyway.

But the guilt I felt constantly for most of my adult life… when Monday came around again, and I'd made no effort to focus on my own goals.

I would feel positive about myself and my job over the weekend. But when Monday rolled on, my positive mentality rolled away. Only to clock in and feel overwhelmed and emotional with the pressure to excel at a job I was starting to dislike. But it pays the bills, right? So, do we carry on…? What do I do?

So, I told my boss the truth. That my perspective on life had changed following our meeting. I told her about my pregnancy, and I explained that I had to follow my dream now. As, in a matter of months, I'd have even less time on my hands to do what I *really* want to do.

I explained to her I was gutted that I wasn't excelling in that role, but I know where my passion lies and wanted to follow that path… in the hopes of excelling there instead.

I'm sure she saw how my eyes lit up with passion explaining why I had made this choice. As she told me, "If I was your mum, I would be so proud of you."

I mean, how would you take that from your boss?!

It was a reaction I had never got before. So, I was certain and content with my decision when she ended the chat and told me to "GO FOR IT!"

A reaction like that is a huge push in itself. Mentally, I was strong now. I was relaxed.

How ironic – I bonded with my boss the day I quit.

It's not '**One Day**' anymore… It's '**Day One**'.

So, I was going to finish my book, this book. I guess though, in the back of my mind, I was kicking myself that I had let this dream go on for so long – I mean, do people even still read books?!

But the simple fact I have made this decision is the clearest most brilliant thing I've ever done. The true happiness that overrides the body, mind, and soul when you are following the right path in life. Your dream. That beautiful internal glow and release that now screams out…

"FUCK ME, I'M ACTUALLY DOING IT!"

I remember how I used to feel, for years, going to sleep with the horrific gut-wrenching feelings of:

"You need to do more."

"You need to be better."

"Make something of yourself."

These thoughts were killing me, and for so much of my past, this guilt and panic of not being good enough caused me to become an insomniac… a depressed insomniac. Fun times.

The sad thing is, this feeling wears off by morning, and so the cycle continues, and we never make any progress.

That has changed for me now, but no one is the finished article; it's about realising there is more left in you.

There is more to you than you think. We're so complex.

Now I am getting up, I'm doing it, I'm putting the time in every day, like I should be. The guilt is gone, and I am truly happy.

It's been a matter of months since I chose to work on me, and I'm a different person entirely. Getting up and doing the work has instilled lessons in me now, that have prepared me.

By trying to change myself for my goal, I have trained myself to be worthy of not just this goal, but any.

Having this mindset and telling the world what I'm working for really has worked too. So much has come into my life already... Financial gains and good news, more love and present living.

I've worked so hard in these months, and already I've created a new version of me. I wish everyone could be this happy.

I am totally in control of my life now. Following my passion, and the power that fills me with, is worth more than anything I've ever done.

Working on something you love brings so much enjoyment.

Enjoyment you should be feeling every day. But instead, we go to work just to wish the day away.

We are ALL strong enough to make it happen.

I wanted to talk for a moment about my late nanna, Betty, the kindest, most beautiful lady, who grew up during the war. She was born in 1930.

It's bizarre to think about how life used to be for our grandparents. Imagine what kind of ambitions they might have had... but never realised, simply because it was the way of the world.

What did my nanna dream of being, on those days when she was completing her role as 'The Perfect Housewife'?

Pristine house, dinner on time, kids in bed, kept face and perfect hair. But what would have been her career path if she could choose her own way?

I wonder if she had dreams and passions in life, like we all do. But, instead, knowing her true potential would never be achieved or worse, respected by the male-dominated world around her.

What would she have loved to do, if she didn't have to give up a career, simply because she had a family?

For our elders, this was life. Appreciate them, please.

Luckily, we know a different world. So, it's about time we stand up for ourselves again, perhaps spiritually this time, and make the change in life that won't only set us free but make us eternally happy, on the inside.

Use this freedom wisely.

When we find and work on what inspires us, we grow in the best ways imaginable. Because, yes, passion will spur you on to put the hours in. When you work on something you love, you internalise a special kind of power. Unstoppable power.

I have no grandparents left and my new baby will only have one. I miss them... so I have to make them proud.

The feelings of guilt I used to feel 24/7 have dissipated completely. I no longer feel any pressure or anxiety because I'm doing it; I am working towards my dream and so, until this is over, I have no angst filling me up.

So now if I want to have a day off – I can. Because I trust myself to get straight back to it. So, for now, I'm going to take a break, and indulge in a guilty pleasure that is watching some of *Ru Paul's Drag Race…* and feel no guilt whatsoever.

We are human. But we are not so different.

I remember thinking I was so different to everyone else growing up, not just with my skin and my strong mentality, but even the little things I did. Example: as a young woman discovering the joys of the power shower, I thought I was brilliant and the only one. "How do I tell the women of the world this magical trick – without outing myself as a horny wanker?!"

But I wasn't alone then, was I…? And I'm not alone now.

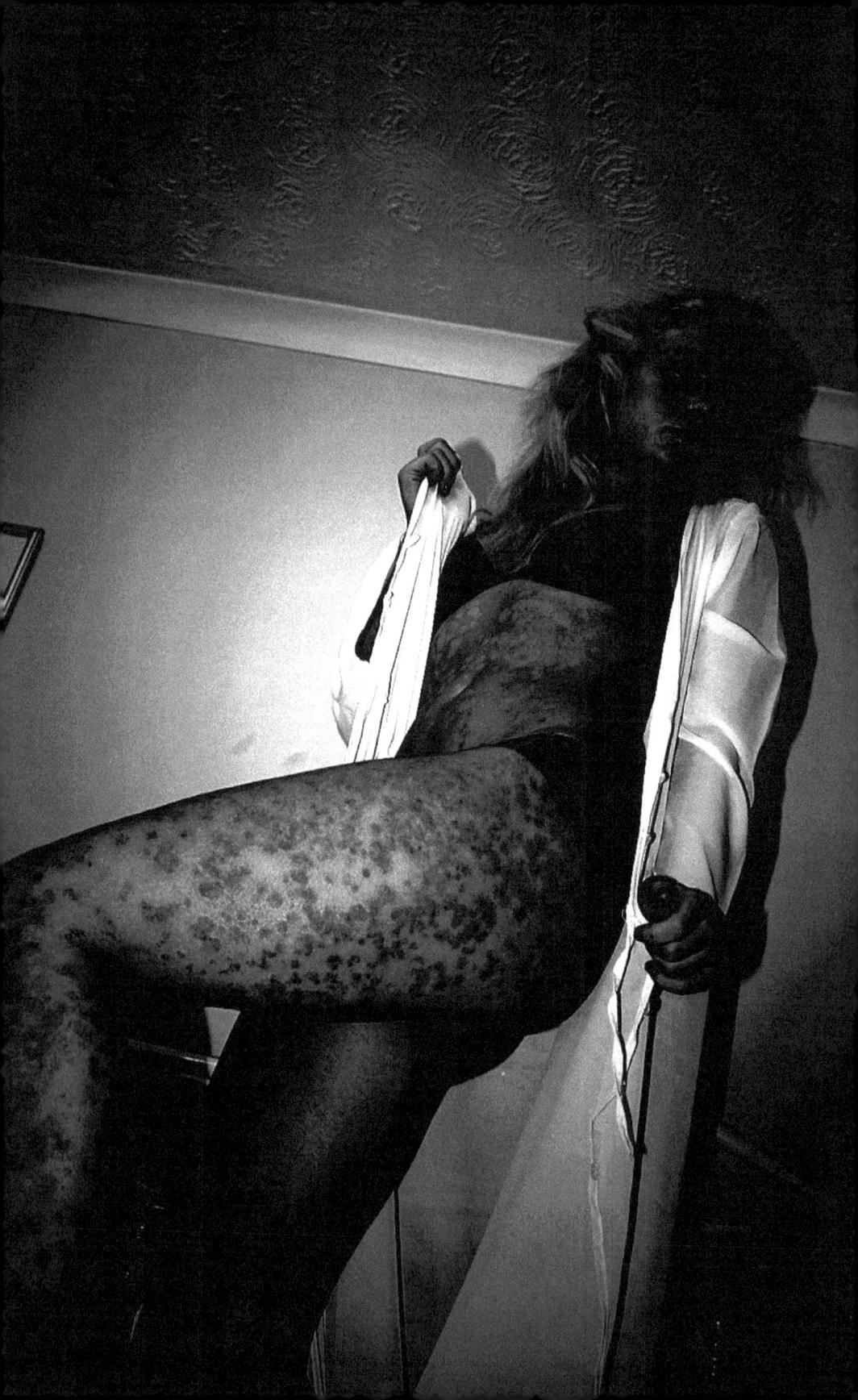

Discipline

Holy mackerel, the day I realised it was discipline needed to succeed, and not motivation, was the day I changed my mindset forever.

I wasted so many years just hoping the motivation would come… "It'll come. When the time is right, it'll all come together!" Starting to think that's bullshit… How about you?

Another sad truth for you is that – if we want an easy life in the future, we have to work hard for it now. And vice versa, an easy life now could mean working harder in the future. – and for longer. That sounds bloody awful, doesn't it?!

Who wants to be trundling away at a job they hate for the next 20 years? Because – if we don't get our asses in gear, we'll be doing exactly that.

- So, what have we learnt so far? Well, we've learnt that the best things in life don't come easily. Seems a bit harsh.

So how do we stay focused on what we actually want? How do we stop life and all its stresses from getting in the way of our dreams?

Why did I wait so many years before deciding to work on *me*??

We all want so much to be happy… and at least financially stable – but we only get about 80 years in this life, on average, if we are lucky.

– And I've wasted 32 of mine.

That's just 80 years… 80 summers, 80 winters, 80 birthdays. When we look at it like this, it really isn't a lot of time, is it? Don't waste it. We focus our lives on the superficial – just going along with the rat race of life. Because, apparently, we've been raised to work, have a family, retire, and die.

So, we hope that if we keep running on that wheel, it'll bring us closer to where we want to be. But the wheel forces us to repeat, over and over again. Never diverting – never thinking outside of the box.

So, what? I guess we're supposed to just repeat the daily life that's sucking us dry… because that's exactly how it feels.

Let's face it, unless we spend our lives doing what we love, we spend our lives wishing we were.

Work specifically... because if this is how we have to buy our happiness – and more crucially our survival – then we had better choose the right job.

Life forces us to stay consistently doing what we believe is needed to survive. WORK.

It hurts to look back at how much time I've wasted... Supposedly 'enjoying life'... but I haven't been, have you?

With what I've been through, I think the majority of my days have been run by feelings of angst, tiredness, guilt, and stress.

It seems that finding the discipline bone inside us is trickier than we thought. We have intentions to do well, to go far. But how many of us actually fulfil our potential?

I seriously think I am a very talented person – I could do so many things... Perhaps though, more like 'Jack of all trades, master of none'.

...But the point is, if I tried to focus and refine even one of my avenues, I may be able to make some money from it. Look, the hope is there. You see, I am essentially just a very hopeful person, I believe in myself. That is all we can do in this life.

...Let's just say for argument's sake, this book is garbage...

I will still be so happy with myself that I finished one task that truly meant something to me. I will have seen through and realised my passion. Something I've been talking and thinking about doing for the last 15+ years.

I really need to get on with it. I can't sit wishing and hoping my life will be all I want it to be if I do nothing but wait.

I cried this morning when I logged into my bank account.

I really don't want to cry over money anymore. But I am working to change that now.

I'm sick of getting screwed.

It seems everyone wants money that I don't have. It's been two months now, surviving on universal credit – if you can call it that.

It's no fun relying on the government, in any sense!

So, why not you? Why not me? We've got the brain power to make plans, make decisions, grow, and change our lives.

What if we chose these things right now?

Our lives will be completely different in just a few years. So, why do we wait?

Because of my skin struggles, I've had to become disciplined with my mentality. Changing negative into positive is the only way I've survived.

There are many ways in which discipline can help us in life.

The most important is disciplining ourselves to stop negative thoughts. We've all heard of manifestation. But it's like God right... Even if you don't believe, it can't be denied.

The things we allow ourselves to think, and feel are absolutely crucial to our mental health.

Allowing negative thoughts in, in any respect, is damaging. So, pick up on them when you do, and try to quickly find a positive response to them.

If we learn to conceive positive replacements for negativity, we will achieve positivity and start imbedding thoughts that make us smile instead.

Manifestation and drive are what pushes me now.

Stop with self-limiting belief systems and negative self-narratives.

It's the number one rule: LOVE WHO YOU ARE.

I realised yesterday, that I have separated myself from the person I once was. I have separated myself from the ones who simply dream. I have become one of the doers in this world.

If I am in this new box, it suits me... just as much as the last.

And now, I am growing a baby with the healthiest mentality I've ever had. I already feel like a better mum, for making myself happy first.

Maybe I am in La La Land... but it feels great. All I have to do is sustain this level of discipline in my self-belief.

It's not delusion, it's sincerity.

Why should negative energy come our way, when we're positive? The truth is it doesn't. Or maybe it has, and I didn't see it because I was able to turn it around so fast...

You don't have to imagine the ins and outs of daily life as a successful person. But instead imagine the things you would do and own, how it would make you feel. And the power to know it can be achieved.

The fact is, when we are at our absolute lowest is when we learn to pick ourselves back up. We've all done it, been through incredible turmoil and still picked ourselves back up.

Hell, most of us do it again and again.

– Life was hard on me when I was hard on myself.

Now I had made a life-changing decision, and I wasn't going to waste it.

I chose my goal, I replaced old habits, I set boundaries for myself, and I stuck to them.

But replacing your core identity with new habits is hard… until you feel really passionately about yourself.

We've lived a certain way, and that's great – as long as we're happy.

I thought I knew what had to be cut out from my life and, coincidentally, they were some of my favourite things.

Having already cut out smoking and drinking, I was left with oversleeping, and lazing around watching TV. TV was sucking my life away. And I had no idea of the power in keeping it off.

It was amazing what happened from just cutting these two things from my daily routine.

I started to celebrate the little wins and feel so proud of myself. Waking up early and getting straight to work. There was no going back and that feeling pushes me so hard.

At first, I did struggle. But I had to claw at this new chance.

There was so much to do, and I was unsure of where to start. At first, I could only make sense of it little by little, but soon enough, I was working the whole day… The school pick-up alarm would go off and I'd realise I hadn't even stopped for lunch.

Because doing something I love created a completely different world for me.

I am now enjoying my work. So, I do more of it. Now, every day, I am a step closer to the end goal. My goal.

I can visualise the end goal, or perhaps just the first, and how my life will begin when this is over.

I was manifesting my ass off. Imagining my life, being able to tell people "I finally did it!" and imagining my family telling me how proud they are of me.

This mentality becomes your motivation to stick to your new lifestyle, because you will feel the benefits. The benefits of having a positive mentality are astounding. Because, really, we've been self-sabotaging for most of our lives.

I had to practice self-control and not give in to the little things that keep me out of commission. Like chilling… too much.

We have to praise ourselves more, especially when we learn to say no.

"The TV is calling, Giorgia. It misses you."

Just say NO! I need to sacrifice a lazy life now, for the lazy life I want in the future.

I will rest when I'm done.

Because now, I have realised my worth.

This in itself is so risky, I haven't won yet. I'm literally still writing, but in my mind, it's going to work. I believe in it so much that I'm writing a book on how to change your life, before it's even changed mine – financially that is, but in every other way, it has totally changed me.

I was already a confident and positive person. But with this passion behind me, focusing on a dream, it did change me.

And now, I'm making it on my own.

I haven't even told my mum I quit my job to follow my dream – I can't, not until I've completed what I'm doing. I can't wait to finally tell her, "I've done it, Mum!"

But for now, I'm done with shouting my dreams from the rooftops. After a certain point, people stop believing in you.

Now, I'm finally getting my head down and making it happen.

I quit my job in August, it's now October.

I can't believe what I've achieved so far. I'm spilling my guts to the world, in the hope that my pictures make the sale and my words hit home.

Because really who am I?

Well, at 13, I was broken when I lost my dad and got bad skin.

At 17, I knew all I wanted was to write and share my pictures.

At 25, I came back from Thailand and finally shared my story.

At 26, I was an ambassador and speaker for psoriasis in Amsterdam. Photos of me covered ten-foot pillars. I modelled my psoriasis for all to see.

At 27, I was on a TV show hosted by Davina McCall and spoke about how stress affects my skin.

At 28, I had my gorgeous baby girl.

And now I'm 32, fighting for what I believe in again. Myself.

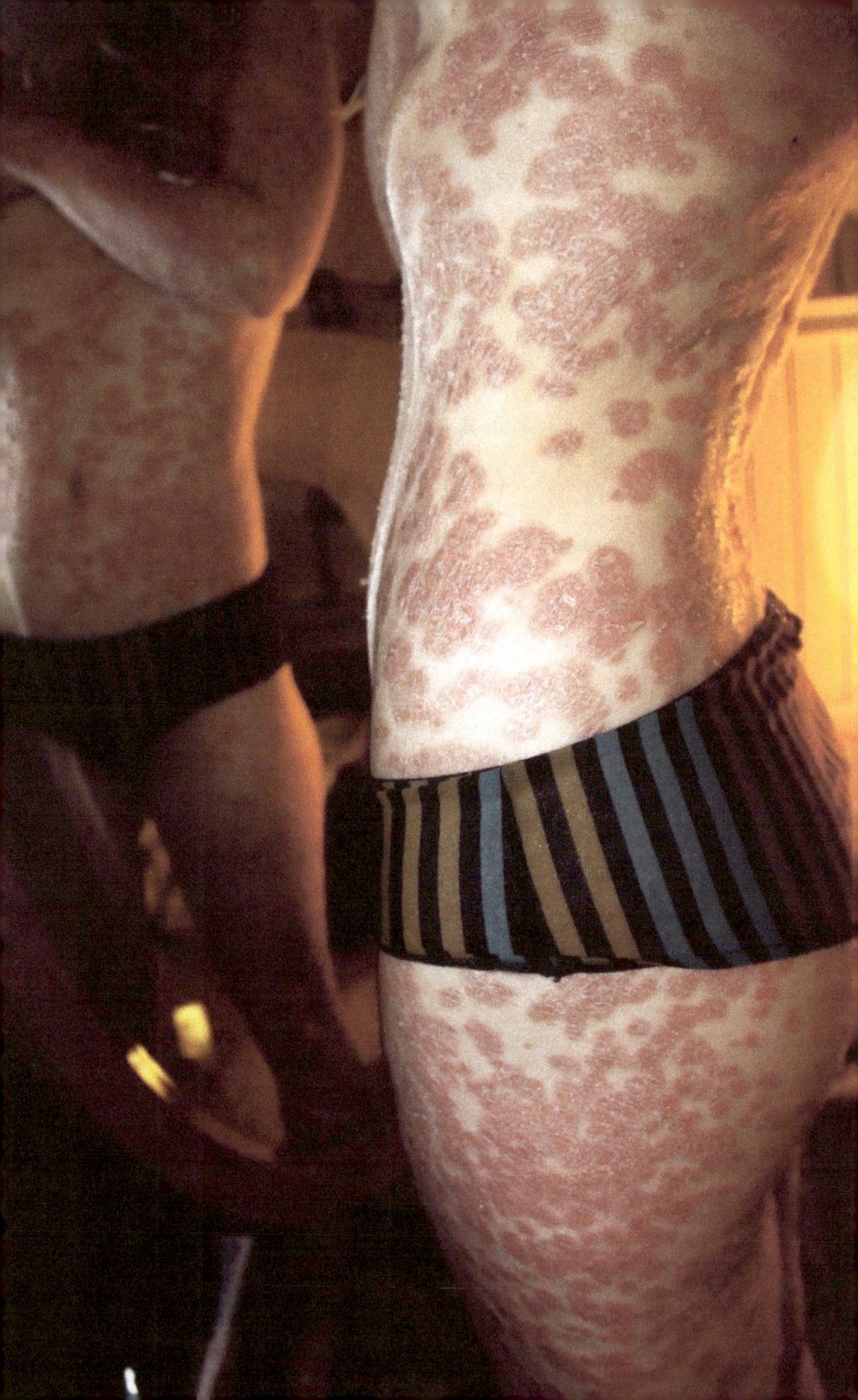

Confidence

We have to find the confidence in ourselves to be the person we want to be. We have to find it, and *be* our full potential, before it's all over.

Research has been done – loads of it in fact – actually proving we can "FAKE IT TILL WE MAKE IT"!

I've been doing this for years as a defence mechanism for my psoriasis being on show. Feigning to the world and my wide-eyed audience that my skin didn't bother me.

I knew I had tricked my brain into believing inner happiness is as easy as a smile.

But it was only when doing research for this book that I found out how many studies into this have been carried out. Our facial muscles *do* influence our emotional state… Because over 130 studies prove you can fake a smile to become happier.

It was amazing to find out that my way of dealing with pain, by faking a smile, was not just my sweet new idea. I knew concentrating on looking confident was overpowering the insecurities and the anxiety I felt. And now, it's been backed up!

This is right where I started, back when I was 13 years old, covered in red, flaky psoriasis and despising my very reflection. Just using these small tricks, lying to myself, and faking a smile and happiness, over time, actually worked *too* well on me – just ask my mum.

I was around 17/18 years old when my mum said to me:

"It's ok to love yourself, Giorgia, but sometimes you can be *too* confident."

And at the time, I'm pretty sure I took that as a plus. My adolescent mind thought that was the compliment to beat all compliments. Retrospectively… it was definitely not intended as such.

But I had gotten to grips with my incurable psoriasis and I knew I was different, in a good way.

So, if we want to 'fake it' we have to pretend, and to practise conditioning our minds not to tolerate negative thoughts.

How I did this, was every time I mentally or subconsciously put myself down or judged myself – I would immediately turn it round and tell myself to "Stop being a plonker, Rodders" or even call myself a "Pussy!" with great passion – and tell myself "I'm better than this!"

'Make it' is when that smile becomes automatic and natural to you... and it will. Soon you find yourself walking down the street smiling and giggling about how far you've come and how happy you are.

Another crazy confidence-boosting trick is to fake confidence in a different way. Simply walking as if you're on a catwalk. It might sound a bit bonkers, but try it...

Chin up. Eyes forward. Be confident.... Now, go get that loaf!

I was stunned at how it made me feel, instantly. I'm only 5"2 and it made me feel taller. Just by not looking at the ground in front of me and trusting the path ahead. I began smiling through my eyes, because when we walk with conviction, we ooze confidence.

Why do we look at the ground anyway? Is it because deep down we worry we'll trip ass over tit, and completely embarrass ourselves? I'm going to hazard a guess and say *yes*.

Certain things in our lives actually condition us to react better and stay safe. We evolve to survive; we all know that.

At the end of the day, we can dumb this down to simply project how you want to be seen. But positivity really does attract positivity. It's no joke. So, stop being a Negative Nancy.

If you can learn to access that, the rest will come. We become what we believe. We can't control everything. But we can control how we carry ourselves and the energy we give off to others.

So, focus on every positive and don't let negativity spill out.

Training your thoughts, and tricking your brain to think positively, is entirely doable. It takes mental strength to control your brain. How ironic... aren't our brains the very things controlling us? So how do we rewire ourselves to committing to changing our own perceptions?

Well, according to scientists, it can take just 63 days for neuroplasticity to occur. This means that our brains can change based on what you're continuously thinking and feeling, generating quantum energy waves through your brain, and causing it to respond electromagnetically and chemically.

For instance, this means that if you tell yourself "You're fucking beautiful" every day, for 63 days… you will believe it!

With this being said, what will you tell yourself from now on?

I know this works – being covered in red dry patches since the age of 13, I spent my teenage years waking up and looking in the mirror, just to burst into tears. My own appearance would shock and depress me – every single morning.

It was so brutal to learn to live with. But I couldn't give up. I knew I had to change how I thought of myself.

I wasn't going to allow myself to keep saying cruel things about my own body – I had to flip the script, completely.

And that feeling changed my life, from such a young age.

I hope I can help my daughter find the level of confidence that I have. I hope she will be as strong as me… now.

My first baby changed my life for the better. Now, I'm pregnant with my second… and life is changing again.

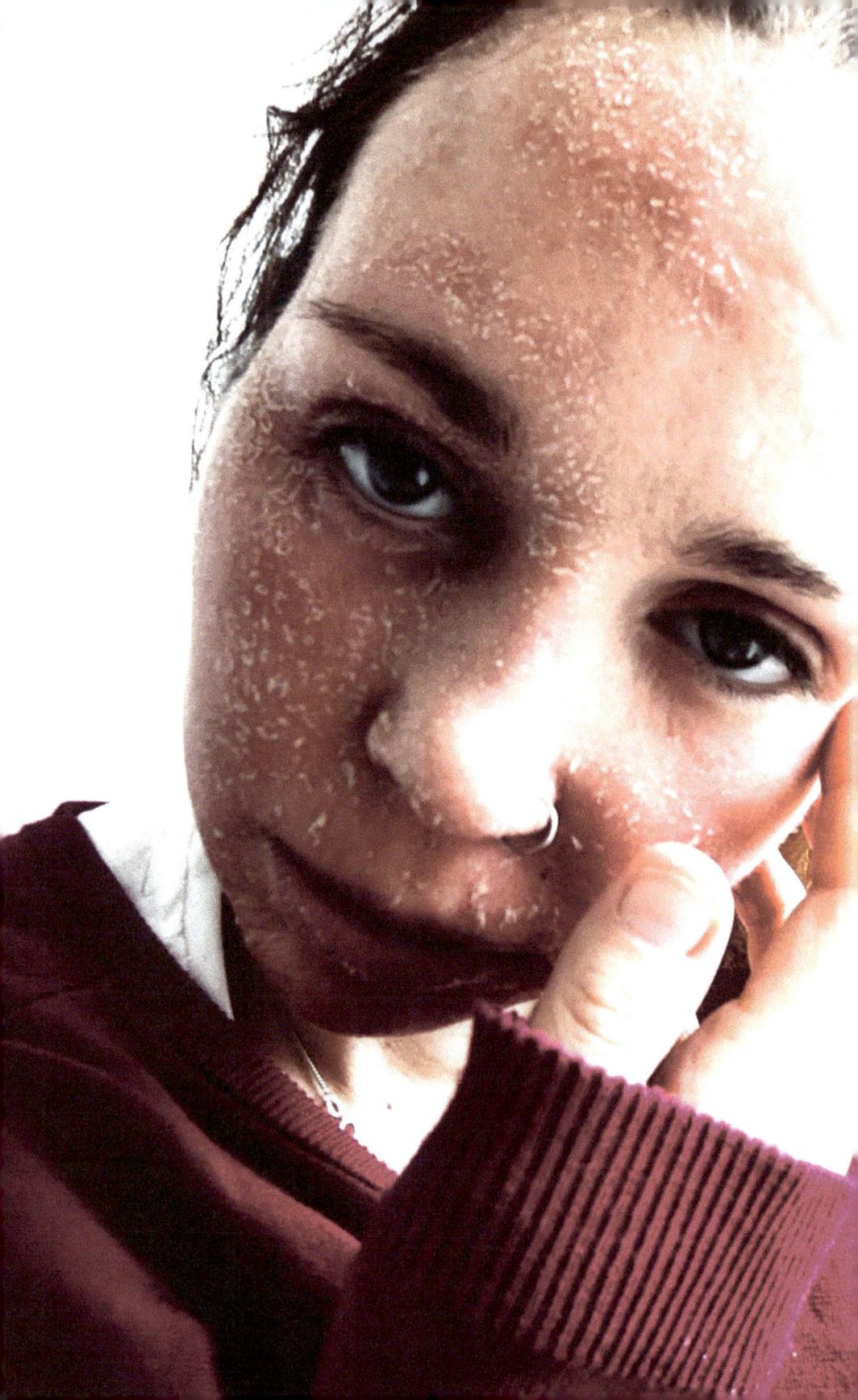

Different Skin

When your skin reacts to life quicker than your mind can, you have to learn to adjust.

And, in my case, I learnt very quickly to try and stay calm inside – despite the brutality life hits us with sometimes.

Being burdened with horrific skin for over 50% of my life has taught me one thing…

Being positive beats medication, any day! I have to stay positive… because, otherwise, it would have killed me by now.

I thought my psoriasis was bad enough… growing up I would think to myself, "G, it can't get worse than this. So, make it your life." But life has a way of getting worse sometimes… doesn't it?

There are others like me all over the world, trying to say the same thing. Maybe my pictures will help, who knows?

I hope they do. Because life can be a little savage and it's up to us to choose how we cope.

When you find confidence in yourself, you find the confidence to find who you are even more, and the confidence to do what you want to do. Why are there so few of us that find and follow our passions?

Surely, we are worth it. Even if we have been downtrodden, beaten or bullied. Even if we've been left alone or pushed away.

The saying: 'People don't change' is definitely bull.

Our mental state can change regularly, causing our opinions, our views, and our routines to change.

Of course, we change. All the time. So be accepting and don't push your opinions on others, because you could feel differently one day. And don't search for advice from the wrong people. Opinions change how we feel – find your own first.

Don't put yourself down and put up with it. Because, one day, you can change it all.

Being a grown-up and running our own life is so daunting sometimes. It could be a simple letter in the post that changes our day from good to bad.

And there you are again, stressed, and worried about your next move.

Your first move is to remember your energy. Don't allow too much negativity to get in the way here.

I didn't know how else to explain to the world what I'm going through, and what I have been through.

What do I do with 18 years' worth of crazy skin photos?

Skin changes that I've documented but never shown, some that only make me proud to have lived all these years, with different skin.

My dad has always been the spirit that pushed me – maybe now I've made it happen, he can rest easy.

My kiddlywinks are my new force. And they are here to see, guide… and, hopefully, one day tell me what my dad never had the chance to: that I've made them proud.

Even if this book bombs – or you just don't get my delightfully quaint humour – I know my dad will be beaming. Just the fact that you're reading this… means you're living my dream.

I hope this book has helped you because it's been a ten-year intention. This has been my long story short – just for you.

I've always wanted to help people. And I've always wanted to write. I know this book will help you, to make you strong, think, laugh or even if you're ever caught short… I'm sure there are a few pages that could come in handy to wipe your troubles away. I just want to help, any way I can…

Admittedly, I'm a bit of a weird one. But I know what I'm talking about.

Please like this book, buy a copy for a friend. Help a girl out.

(I really hope you're laughing too)

That's probably the first thing we learn to do, isn't it? Take the mickey out of ourselves, before anyone else gets the chance…

I understand the risk in what I'm doing here. That's why I'm writing about it.

I'm not sure it's even worth asking myself what happens if this doesn't work. I know the world shouldn't work like that. If I wish, I hope, I try and I work insanely hard to achieve what I want, why shouldn't it work?

It's karma if nothing else. And I trust in that.

I have faith in this world and the people in it. Because once I send this over. It's out of my hands. And in yours, hopefully. And then, I will be literally relying on others to make my dreams come true.

That's crazy, right?

So, thank you in advance if you are reading this now.

I can't be bothered to have money struggles anymore, so I have to be bothered to do something about it. But yesterday I was finally able to pay a bill that's been hanging over me… and as I completed said task, I put a tick and a smiley face on the top corner – without even thinking.

I had just marked my own work.

I cracked up at myself… and then proceeded to write: *Good Work!* – Because we need appreciation and gratitude in life.

But there are people out there who would celebrate the opening of an envelope. And maybe that's what we need.

To celebrate ourselves daily, but without having the party.

My 30's so far, however, have consisted mostly of me watching *The Repair Shop* with zoot in hand – a guilty pleasure at its finest. But I could do any task after that and feel happy.

Thank God for our kids, correcting us even before they're born. Pregnancy is hard, right? Giving up the things you love.

But how good do we feel when we start to see our lives functioning more smoothly, without these things, dragging us down?

I no longer spend my free days melting into the sofa.

And being 'sober' I guess has taught me an 'If I do this now, I can do that later' mentality. I now wake up, clean up, work hard, get my girl from school, cook, clean again and then I can watch TV… But even TV has started to bore me.

The programmes I used to watch, no longer tickle me. Because now I'm looking for more than just silly comedy.

It's the price you pay. And I'm happy to. I was changing in a lot of ways.

But with my pregnancy going great, minus feeling a smidge like a whale, I was seeing my medication wear off and my psoriasis returning. I didn't expect it to come back this quick, or fierce.

But what of our partners through all of this? Supporting us each day… waking up covered in skin that isn't their own.

As much as we appreciate that they put up with our fairy dust. Love is love. And we are all worthy of it. And our skin differences will never change that.

So, believe them when they say they love you, just the way you are.

And don't cover up your body around them, learn to show yourself.

And then when you *are* in the mood, you *will* make the move.

We've all heard the saying 'You've got to be in it to win it', but it's not true just of the lottery; it's true in life.

By being present and happy, we are already winning. We can't win at life if we are not prepared to put ourselves into it.

I stopped believing in God when I lost my dad. I was sick of constantly feeling smited. But I was hurt. I now believe in my family being up there, in very much the same way.

So, it's up to me to do this for myself. And I've got my ticket.

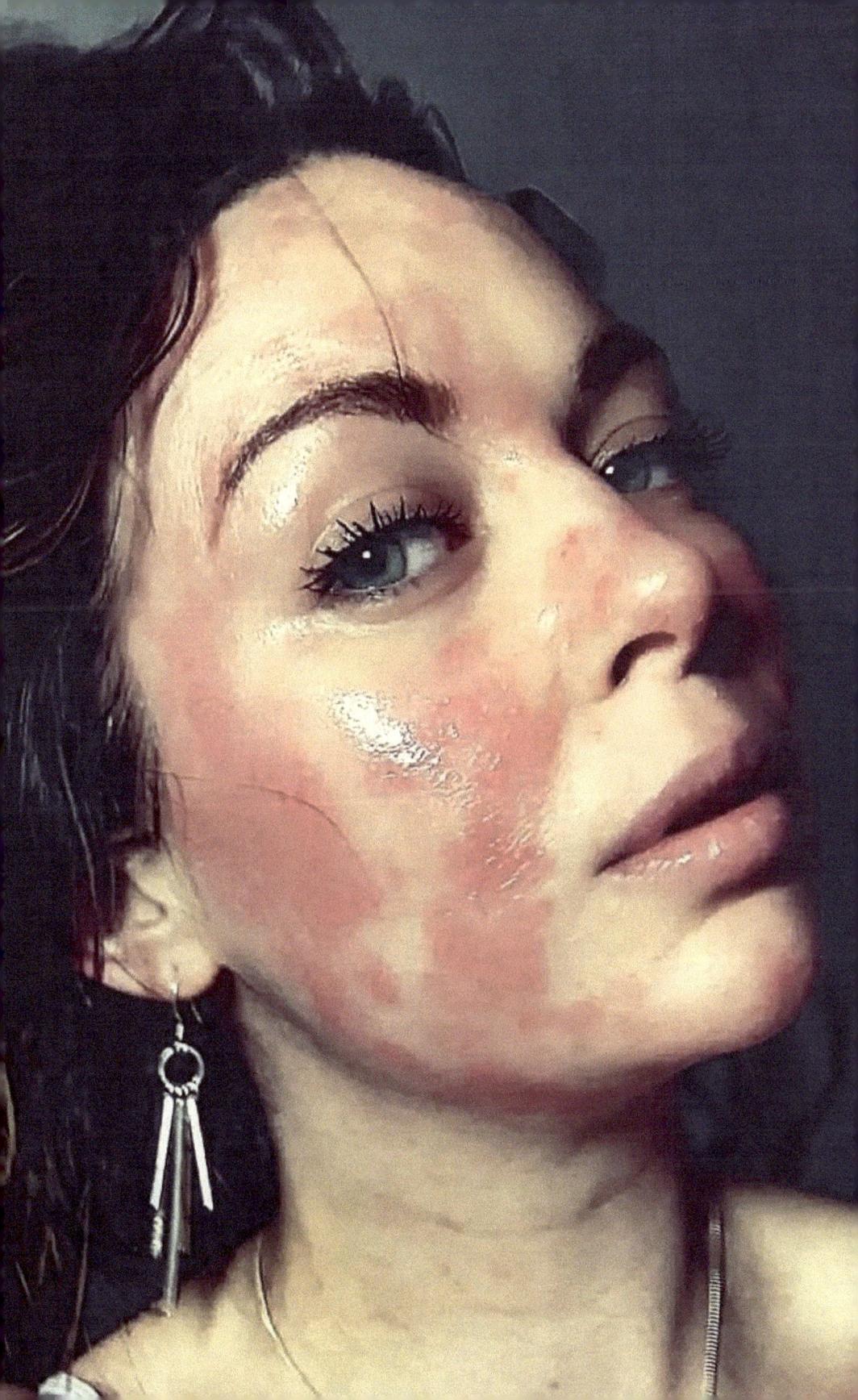

Healing

What if life isn't happening to us... but instead happening for us? And to become whole we have to overcome and learn through the heartaches. What if there are no mistakes in life... only lessons?

What if we are EXACTLY where we're supposed to be?

What if we are given these tests to shape us? And it's only through our own choices that we progress?

Would we be superhuman if we were to deal with life's lessons as if the silver lining was obvious to us?

I know dealing with so much loss has taught me to appreciate the family I have left, regardless of hardship, resentment, or stubbornness.

It's taught me to look at the world differently... starting with empathy and compassion for others.

We need to stop thinking and internally bitching about that person that didn't say thanks when we gave way...

Laugh instead and negativity has a harder time situating itself in our minds.

Arguments can stay with us. But let go of things you can't control. Stop wishing you had *said that* or acted differently.

Don't send that hurtful reply in the early hours because you've finally found the words – WHAT'S THE POINT?

What you can't change shouldn't be able to eat you up at night.

With the people around me dropping like flies, I no longer judge others, or first impressions.

If someone is rude or aggressive to me... it could be because they're having a bad day or maybe they've just had some bad news.

Because thinking people hurt us for no reason is ridiculous – and simply assuming they are a 'horrible person' is not the conclusion you want to come to.

I hated when I used to get angry and would cringe afterwards with the realisation that I needed to practice calm and patience if I was going to heal from my trauma.

I know I am not alone in being the black sheep of the family or feeling shunned or isolated. But it teaches us to get stronger, to stand on our own two feet and to protect ourselves, mentally.

Feeling powerless or downtrodden teaches us to take our power back and focus on our own independence and mental strength.

Perhaps your partner or loved one does something that irritates you? We can nitpick so much in life that the small stuff gets to us and soon we forget all the good parts about a relationship. No one is perfect.

But be choosey about who you give your love to – because some don't deserve it. Don't allow yourself to be treated badly. Ever!

And if this is the case for you, get out.

Get out of that harmful relationship! You can be strong alone – because that's how it starts!

Think about the strained relationships you may be dealing with. Is this supposed to teach us unconditional love? Or, in fact, the strength to speak up and stand up for ourselves?

Go with the latter.

The point is, we have to learn to change what we are not happy with, and to find the meanings that we believe can change our lives for the better.

"The best healing is finally realising you're not broken, and you don't need fixing."

Danu Morrigan

We are all learning to deal with the stress of uncertainty in life.

So, stop stressing, kid, you'll get through this.

We learn at different paces. And all we can do is try.

Keep going UP.

Remember always to look after number one and be kind to yourself. Don't put too much pressure on your shoulders. Some people deal with anxiety and life's unpredictability better than others.

So don't beat yourself up if you deal with things differently.
But also, don't let your coping strategy delay your success... like I did.

Reflect on your happiest moments and past successes. – You can't progress in life if all you think of are your failures!

Don't let stress-release solutions become damaging. Pick yourself up, stay healthy by eating well, exercising, and getting enough sleep... It's not new advice, but it works.
...And it took me long enough to jump on that bandwagon!

This is the place to start if you're unsure of where to go, or where your position is in this world. I've felt it so many times.

But we have to start somewhere. If your life is not where you want it right now, make small changes to your routine.

From now on, find a positive reason for the struggles and don't dwell on what you can't change.

I avoid watching the news now. I am just about strong enough to cope with my own struggles, but not strong enough to see the rest of the world in so much pain.

There are things in the world I alone cannot change... So why do world issues hit me so hard and affect me so much?

I am too much of an empath, I think. I cry simply from seeing someone upset, and that upset used to consume me. I was so angry at the world... filled with so much aggression and sadness.

So yes 'Out of Sight, Out of Mind' does work. Call me naïve but sometimes, I have to stop worrying about the rest of the world and focus on MY WORLD – the world I can control. Literally.

"We are the producer, director, and actor in our own play. If you don't like how this scene is going? Change it!"
Dolores Cannon

We have to learn to calm our own storm instead of venting – all this does is reinforce negative thoughts. If we can learn to take the right path at moments like these, we will be a lot happier. Just remember what kind of energy you're releasing into the world.

The thing is when we vent to others – it's generally because we are riled up. And then we find a loved one to dump our problems onto… right?

Whether they like it or not… apparently.

But, what if the loved one you have chosen isn't in the right headspace to receive your negative energy? What if your bitching companion is struggling with their own world? Can we just skip the bitching and get to the positive outcome?

Learning to turn these thoughts around, and understand why things may be happening to us, is healthier than what we've been doing.

It is up to us to pull ourselves out of negativity – as much as we rely on loved ones, it just isn't fair sometimes.

Meditation, deep breathing, or even learning to write our thoughts down, just to throw away… and LET GO!

But, what if instead of grabbing pen and paper – we just want to tell the world to "FUCK OFF AND LEAVE US ALONE!"

The fact is, it's true. Really… we can only rely on ourselves to find those silver linings and lessons from it all.

Because it starts and ends in *your* head, no one else's.

One of the best sayings I've ever heard is:

Our ego says, "Once everything falls into place then I will find peace and happiness."

But spirit says, "Once you find peace and happiness then everything will fall into place."

When I speak to my loved ones up there, or wherever they may be, I sometimes have to switch from English to Italian depending on who I'm speaking to… but I have to speak to them.

I thank them. I thank my dad, my nonna, my nanna and my grandad. I thank George. I thank them all for having a hand in my life with or without them, when they were here and now they're not.

Losing someone breaks us.

But hoping they are still there, helps us heal.

Maybe I'm not depressed, I'm still grieving.
Maybe I'm not lazy, I've run out of energy.
Maybe I am ok, I'm just judging myself.

We find it so easy to just 'ACCEPT ALL'. We accept terms and conditions like they have always looked after our best interests. They haven't.

We accept updates to our phones, without knowing what they're changing.

We accept fees, bill increases – we accept being the little man in this huge world.

We get screwed left and right. So, we have to stop this 'ACCEPT ALL' mentality in our own lives, and finally stop accepting unhappiness.

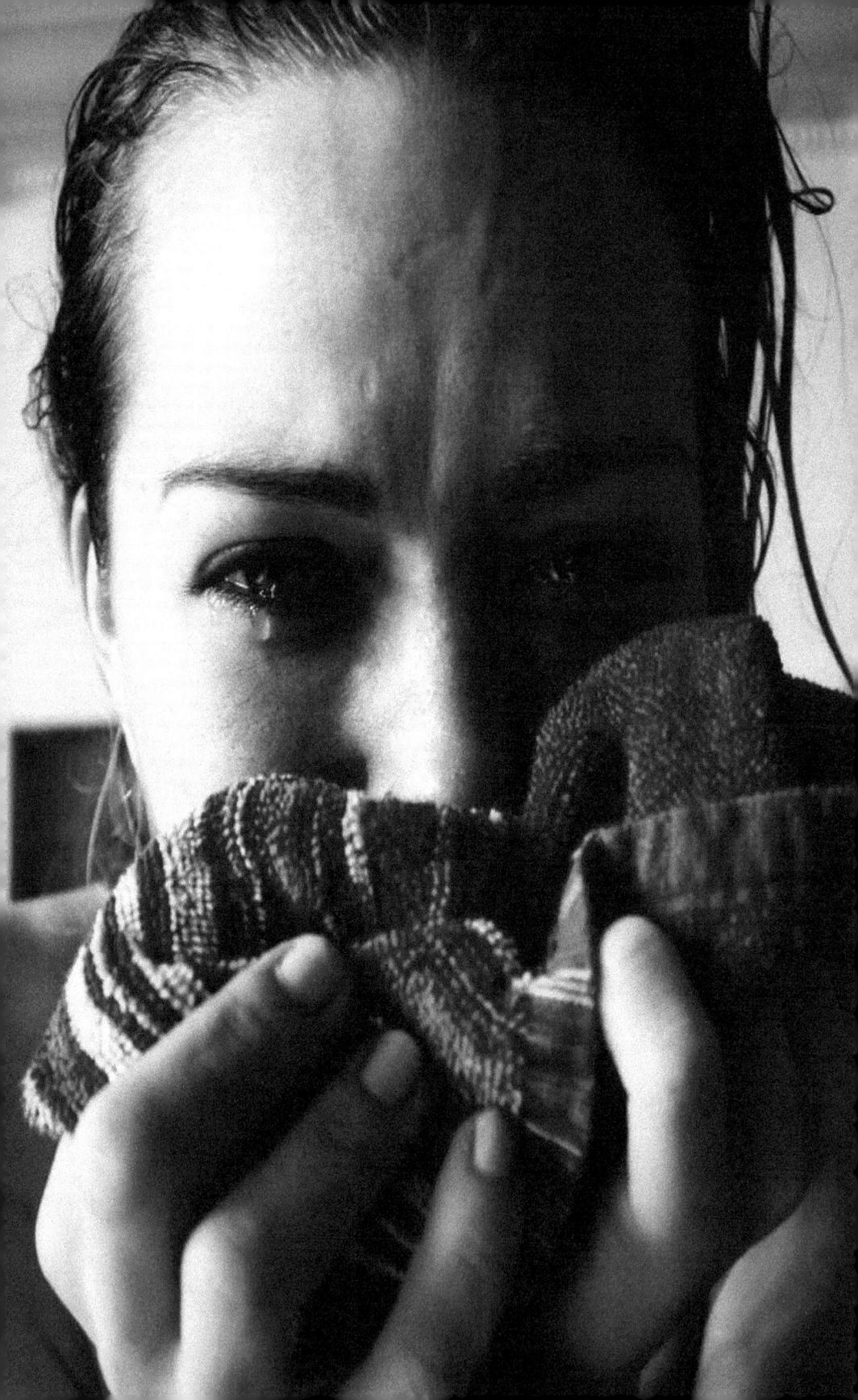

Thank You

Thank you, Alex. For not questioning a thing when I quit my job, and truly being behind me from day one – and giving that much love and support, while having no idea whether or not I would make a tit of myself, or even fail. I hope you like this book and finding out why I am the way I am. Realising the me before you. Before you came into our lives and changed it for the better... a better I had no idea could exist.

Thank you, Mia. I have been so happy since we've been reunited, thanks to our girls. You have helped me more than you know. You have kept me positive; you have kept me laughing, and you have kept me on track. But, most of all, you have hoped and believed in this book almost as much as I have. You know how much I want this to work, and your friendship has made that happen.

Thank you, my babies, my gorgeous Tahlia. No words can ever express the love I have for you. My sweet girl. One day, when you are a teenager and giving me gip, I will show you this book and hope you will be my best friend. I love you, darling.

Thank you, to my kicking baby, even though I'm still carrying you... you have felt my true euphoria and love while writing this book. We've been growing together this whole time. I will do anything for you, like my family have done for me. I love you.

I'd like to thank my mum and dad, for having an equal hand in my beautiful life and gifting me with an incurable disease.
Without them, this book would not be possible.

...So, if you're not 100% satisfied with your purchase, always blame the parents!

PS… THIS IS A POEM I WROTE FOR MY DAD.

I felt a ghost and carried it with me,
I long forever to find my reality.
He comes and goes, under the wind.
I've made so many bad choices, and they show on my skin.

www.ingramcontent.com/pod-product-compliance
Lightning Source LLC
Chambersburg PA
CBHW051211090426
42740CB00022B/3467